Renaissance Art: A Very Short Introduction

Very Short Introductions available now:

ADVERTISING Winston Fletcher
AFRICAN HISTORY John Parker and
 Richard Rathbone
AGNOSTICISM Robin Le Poidevin
AMERICAN POLITICAL PARTIES AND
 ELECTIONS L. Sandy Maisel
THE AMERICAN PRESIDENCY
 Charles O. Jones
ANARCHISM Colin Ward
ANCIENT EGYPT Ian Shaw
ANCIENT PHILOSOPHY Julia Annas
ANCIENT WARFARE Harry Sidebottom
ANGLICANISM Mark Chapman
THE ANGLO-SAXON AGE John Blair
ANIMAL RIGHTS David DeGrazia
ANTISEMITISM Steven Beller
THE APOCRYPHAL GOSPELS
 Paul Foster
ARCHAEOLOGY Paul Bahn
ARCHITECTURE Andrew Ballantyne
ARISTOCRACY William Doyle
ARISTOTLE Jonathan Barnes
ART HISTORY Dana Arnold
ART THEORY Cynthia Freeland
ATHEISM Julian Baggini
AUGUSTINE Henry Chadwick
AUTISM Uta Frith
BARTHES Jonathan Culler
BESTSELLERS John Sutherland
THE BIBLE John Riches
BIBLICAL ARCHEOLOGY Eric H. Cline
BIOGRAPHY Hermione Lee
THE BLUES Elijah Wald
THE BOOK OF MORMON Terryl Givens
THE BRAIN Michael O'Shea
BRITISH POLITICS Anthony Wright
BUDDHA Michael Carrithers
BUDDHISM Damien Keown
BUDDHIST ETHICS Damien Keown
CAPITALISM James Fulcher
CATHOLICISM Gerald O'Collins
THE CELTS Barry Cunliffe
CHAOS Leonard Smith
CHOICE THEORY Michael Allingham
CHRISTIAN ART Beth Williamson
CHRISTIAN ETHICS D. Stephen Long
CHRISTIANITY Linda Woodhead
CITIZENSHIP Richard Bellamy
CLASSICAL MYTHOLOGY Helen Morales
CLASSICS Mary Beard and John Henderson

CLAUSEWITZ Michael Howard
THE COLD WAR Robert McMahon
COMMUNISM Leslie Holmes
CONSCIOUSNESS Susan Blackmore
CONTEMPORARY ART Julian Stallabrass
CONTINENTAL PHILOSOPHY
 Simon Critchley
COSMOLOGY Peter Coles
THE CRUSADES Christopher Tyerman
CRYPTOGRAPHY Fred Piper and
 Sean Murphy
DADA AND SURREALISM David Hopkins
DARWIN Jonathan Howard
THE DEAD SEA SCROLLS Timothy Lim
DEMOCRACY Bernard Crick
DESCARTES Tom Sorell
DESERTS Nick Middleton
DESIGN John Heskett
DINOSAURS David Norman
DIPLOMACY Joseph M. Siracusa
DOCUMENTARY FILM
 Patricia Aufderheide
DREAMING J. Allan Hobson
DRUGS Leslie Iversen
DRUIDS Barry Cunliffe
THE EARTH Martin Redfern
ECONOMICS Partha Dasgupta
EGYPTIAN MYTH Geraldine Pinch
EIGHTEENTH-CENTURY BRITAIN
 Paul Langford
THE ELEMENTS Philip Ball
EMOTION Dylan Evans
EMPIRE Stephen Howe
ENGELS Terrell Carver
ENGLISH LITERATURE Jonathan Bate
EPIDEMIOLOGY Roldolfo Saracci
ETHICS Simon Blackburn
THE EUROPEAN John Pinder and
 Simon Usherwood
EVOLUTION Brian and Deborah
 Charlesworth
EXISTENTIALISM Thomas Flynn
FASCISM Kevin Passmore
FASHION Rebecca Arnold
FEMINISM Margaret Walters
FILM MUSIC Kathryn Kalinak
THE FIRST WORLD WAR
 Michael Howard
FORENSIC PSYCHOLOGY David Canter
FORENSIC SCIENCE Jim Fraser

For more information visit our web site:
www.oup.co.uk/general/vsi/

Geraldine A. Johnson

RENAISSANCE ART

A Very Short Introduction

OXFORD
UNIVERSITY PRESS

OXFORD
UNIVERSITY PRESS

Great Clarendon Street, Oxford OX2 6DP

Oxford University Press is a department of the University of Oxford.
It furthers the University's objective of excellence in research, scholarship,
and education by publishing worldwide in

Oxford New York

Auckland Cape Town Dar es Salaam Hong Kong Karachi
Kuala Lumpur Madrid Melbourne Mexico City Nairobi
New Delhi Shanghai Taipei Toronto

With offices in

Argentina Austria Brazil Chile Czech Republic France Greece
Guatemala Hungary Italy Japan South Korea Poland Portugal
Singapore Switzerland Thailand Turkey Ukraine Vietnam

Oxford is a registered trade mark of Oxford University Press
in the UK and in certain other countries

Published in the United States
by Oxford University Press Inc., New York

British Library Cataloguing in Publication Data
Data available

Library of Congress Cataloging in Publication Data
Data available

ISBN 978-0-19-280354-2

7 9 10 8

Typeset by RefineCatch Ltd, Bungay, Suffolk
Printed in Great Britain by
Ashford Colour Press Ltd, Gosport, Hants.

To Chris, my Renaissance man.

Contents

Acknowledgements

For their help and support while planning and writing this book, I would like to thank my fellow 'students' at Christ Church, Oxford, and especially my colleagues in the Department of History of Art at the University of Oxford: Martin Kemp, Marius Kwint, Gavin Parkinson, Katerina Reed-Tsocha, Linda Whiteley, Vicky Brown, Nicola Henderson, and Laura Iliffe. Staff and colleagues in the Modern History Faculty and the Sackler Library in Oxford have also been invaluable in completing this volume, as have my editors at Oxford University Press, Marsha Filion and Katharine Reeve, and my copy editor, Alyson Lacewing. My graduate students at Oxford have, perhaps unwittingly, served as guinea pigs on which to test some of the ideas presented here, for which I am very grateful.

My wise and wonderful parents, R. Stanley and Ursula Gustorf Johnson, have always been my greatest champions. In the case of the present book, they were also the first to read the manuscript and very kindly provided a key illustration, both reflections of their own deep appreciation and understanding of Renaissance art. My family and friends, both near and far, have given me much enthusiastic support during the preparation of this book. I am especially thankful to: Gregoire, Kristine, and Kristof Johnson; Doris and Hans Schmeling; Peter, Judy, Sarah, and Jane Martin; and Tania String. Last but certainly not least, my amazing husband, Chris Martin, was absolutely crucial to my completing this volume, not only by providing much love and

encouragement, but also by patiently listening to my latest half-baked ideas for the text and making sure that a steady supply of high-energy snacks was available while it was actually being written. It is to him, a true Renaissance man for the 21st century, that I dedicate this little book *con tantissimo amore*.

List of illustrations

The publisher and the author apologize for any errors or omissions in the above list. If contacted they will be pleased to rectify these at the earliest opportunity.

Chapter 1

Introduction: whose Renaissance? whose art?

'Art' in the Renaissance

The year is 1768. Johann Wolfgang von Goethe, at the time a mere law student, but soon to become Germany's most famous poet-philosopher, steps into Dresden's new art museum for the first time and describes the scene:

> ... the profound silence that reigned, created a solemn and unique impression, akin to the emotion experienced upon entering a House of God, and it deepened as one looked at the ornaments on exhibition which, as much as the temple that housed them, were objects of adoration in that place consecrated to the holy ends of art.

One of the works he would have admired was Raphael's *Sistine Madonna* (Figure 1), acquired in 1754 by Dresden's ruler, Augustus III of Saxony, but familiar to us today from countless Christmas cards, posters, and knick-knacks featuring the painting's cherubic pair of plump child-angels. For Goethe, seeing such works in the hushed atmosphere of Dresden's picture gallery was a quasi-religious experience in which paintings were worshipped as the aesthetic relics of semi-divine artistic geniuses. Still today, when we gaze reverentially at paintings, sculptures, and drawings by Renaissance masters such as Raphael displayed in the temple-like

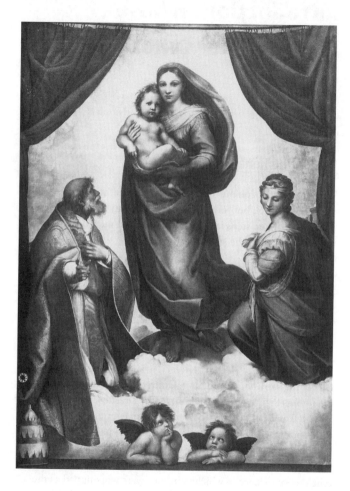

1. Raphael Sanzio, *The Sistine Madonna*, oil on canvas, c. 1512–14

surroundings of art museums, we continue to treat them like objects worthy of aesthetic worship and almost mystical visual contemplation.

The *Sistine Madonna*'s original 16th-century beholders, however, did not see religion merely as a kind of metaphor for the appreciation of art, but rather encountered such paintings within the context of actual religious rituals. For the *Sistine Madonna* was not really a work of art as Goethe or, indeed, any of us today would understand the term. Instead, it was first and foremost a devotional image with very specific ritual purposes. It was, in short, an altarpiece.

We will be considering the altarpiece as a genre or type of art in the second chapter. For the moment, however, it is crucial to understand that, no matter how familiar such works may seem to our eyes, we should not simply assume that we can 'see' them in the same way that their Renaissance beholders did. Instead, the concept of 'Art' itself must be contextualized through the 'period eye' of 15th- and 16th-century beholders. As we shall see, many of the paintings, sculptures, and drawings by Renaissance artists now displayed in museums or highlighted in tourist guidebooks as artistic masterpieces would originally have been evaluated not only or even primarily in aesthetic terms, but rather viewed as functional objects with carefully selected iconographies produced for defined sacred or secular purposes that had evolved from venerable and often still-ongoing traditions. At the same time, it is precisely during the Renaissance that the modern concept of 'Art' (with a capital 'A') first began to emerge, together with related notions about the status of the artist as creative genius, the importance of originality (rather than craftsmanship) in assessing the merit of art objects, and the significance of using aesthetic criteria to judge works of art – subjects that we will consider briefly below and, at greater length, in several of the following chapters.

Reconsidering the Renaissance

However, it is not only the term 'Art' that we need to consider carefully. In fact, the first part of this volume's title, 'Renaissance', is also more complex than may appear at first glance. The word literally means 'rebirth', but has come to be associated more generally with revival and innovation, often in a variety of fields of endeavour. So, for example, we speak of the 'Harlem Renaissance' when describing the new flourishing of art, music, dance, and literature in New York City's African-American community in the 1920s, while everyone from Benjamin Franklin to Apple's Steve Jobs has been called a 'Renaissance man' thanks to having multi-faceted interests and innovative ideas.

But if we want to use the concept historically, rather than metaphorically, we need to ask when and how it was first deployed. Most scholars agree that the notion, if not the word itself, can be traced back to 14th-century Italy and the rise of humanism. In this period, writers such as Petrarch and Boccaccio began to articulate a longing for the Classical world of ancient Greece and Rome, with particular emphasis on reviving the languages and intellectual traditions of these long-dead civilizations. In the mid-16th century, the painter and art historian Giorgio Vasari used the Italian version of the word 'Renaissance', *rinascita*, to refer explicitly to the revival not only of the artistic standards and literary prototypes of the Classical age, but also to distinguish the art of the present from that of the more recent Medieval past. For Vasari, in other words, 'rebirth' was not only about reviving the visual culture of ancient Greece and Rome, but also about differentiating Renaissance art from its supposedly 'dark' and dreary immediate predecessors. In fact, it is this sense of historical self-awareness, of seeing oneself and the culture of one's own time as somehow different and distinct from that of the past, both near and distant, that is perhaps the most important hallmark of the humanist Renaissance.

Since the mid-19th century, historians such as Jacob Burckhardt

have popularized the notion of the Renaissance as a distinct and highly self-aware historical period that was the direct precursor of our present-day (and even more self-aware) modern world. It was also Burckhardt, in his influential book on *The Civilization of the Renaissance in Italy* (1860), who first made explicit the idea of the Renaissance as a period in which multi-talented 'universal men' consciously sought to use the Classical past as an inspirational model for creating a new age of enlightenment in fields as diverse as science, art, and politics, a subject we will be considering again in Chapter 4 when we explore the role played by the close observation of nature and the use of antique models in Renaissance artistic practices. The Burckhardtian notion of the ideal 'Renaissance man' as an *uomo universale* will also re-emerge in the fifth chapter, when we explore the rise of individual portraiture as a genre in this period, while the status of and role played by Renaissance *women* in the realm of the visual arts will be considered in the sixth chapter.

But was the Renaissance only about developing a new sense of individuality and displaying a conscious preference for revival, change, and progress? And did everyone throughout Europe really have a 'Renaissance', either literally or metaphorically? Despite the best efforts of Burckhardt and his many followers to convince us otherwise, the answer to both questions is 'no'. In the case of a small band of elite humanist scholars, patrons, writers, and artists working first in Italy in the 14th century and then, in the 15th and 16th centuries (the time span that will be the focus of this book), throughout Europe, there clearly was an explicit desire to turn to the Classical past for inspiration in creating a new intellectual, artistic, and literary culture in the present. But for by far the vast majority of people living in Italy, France, Spain, Germany, Britain, and the Low Countries in this period, life went on pretty much as before on most fronts. It would thus be difficult to speak of a 'Renaissance' occurring in any significant sense in the lives, beliefs, and experiences of, say, an Italian silk weaver, an English farmer's wife, or a French blacksmith.

The great exception was religion. Until the early 16th century, the religious life of European men and women was essentially a continuation of long-standing Medieval rituals and traditions, with regional variations and shifts of emphasis but generally remaining fairly constant over several centuries. This was true for the elite as well as for those of less exalted social and economic status. But in the early 16th century, the challenges of the Protestant Reformation, led by charismatic figures such as Martin Luther, signalled a radical break in the religious life and outlook of European society at all levels. One can thus see 'Renaissance art' or 'Renaissance literature' as consciously encouraging new, progressive, and often Classically inspired styles and subjects associated with elite patrons and the artists and writers they favoured, especially in the secular realm. But it would be anachronistic to speak of 'Renaissance religion' given the general continuity with the immediate past that existed in this area until the early 16th century. Instead, it would probably make more sense to mark a division between 'late Medieval' and 'post-Reformation' or 'Early Modern' culture when considering the question of religion – with 'Early Modern' being a term used by academics in recent decades to indicate a period stretching from approximately the 16th to the 18th centuries, and one that is perhaps less heavily burdened by the associations and assumptions that have become attached to the word 'Renaissance' since Burckhardt's day.

Art, artists, and patrons

The tensions between continuity and change in this period can be seen in the many different types of images and objects produced in 15th- and 16th-century Europe. While many of these items would not look out of place in a present-day art museum or, indeed, in the Dresden picture gallery visited by Goethe in the later 18th century, it is important to keep in mind that none was originally made for such surroundings. Indeed, the great majority would not have been viewed as 'works of art' in the first place, at least not in the modern

sense of the phrase. That is, they would not have been understood as somehow making concrete an individual artist's personal beliefs, emotions, and experiences. Instead, it was the taste, desires, and needs of the patron who commissioned them that were meant to be expressed in such objects.

Likewise, artists were not social outcasts and intellectual rebels, starving in garrets due to conventional society's inability to appreciate their forward-thinking vision and genius. Rather, the successful Renaissance artist was usually a member of an often rather conservative trade group known as a guild or, in the later 16th century, was perhaps affiliated with a state-approved art academy, both of which guaranteed the patron a certain level of competence – as well as guaranteeing the artist a reasonable stream of income. In order to win commissions from wealthy patrons in the first place – patrons who included individuals ranging from popes and princes to patricians and well-to-do citizens, as well as larger organizations such as town councils, guilds, confraternities, and religious orders – artists had to conform to the social, political, and devotional expectations of their paymasters. Although, as we shall see in the final chapter, the status of a small number of 'superstars' such as Michelangelo Buonarroti and Albrecht Dürer did allow a new notion of the artist as a visionary and sometimes even eccentric genius to begin to emerge in this period, the vast majority of Renaissance artists were successful precisely because they were considered to be sufficiently steady, skilful, and reliable to be entrusted with executing a particular commission exactly as the patron had intended.

Similarly, the majority of objects and images produced in the Renaissance would not have been assessed primarily as works of art in aesthetic terms, that is, by considering their style and composition, as well as how they fit into a grand art historical narrative organized chronologically around the notion of formal artistic 'progress' and 'development'. Such criteria, however, are precisely what have been used when deciding how to display most

7

Renaissance paintings, sculptures, and drawings in present-day museums, where the rooms are arranged chronologically by artistic 'school' and the wall labels list only the artist's name, the date, and the title of the work, usually to the exclusion of any more detailed contextual information. As was already the case in Goethe's day, the museum itself is silent and devoid of unnecessary distractions, so as to enhance our ability to worship the art object on its own aesthetic terms, to appreciate 'art for art's sake', as the 19th-century bohemian intellectual Théophile Gautier put it.

But in the Renaissance, the situation was very different. Although over the course of the 16th century, a small number of patrons and collectors did begin to acquire and display paintings, statues, and drawings at least in part based on aesthetic criteria that we would recognize today, such as the reputation of the artist or the originality and beauty of the work on its own terms, by far the largest number of objects and images fulfilled very different functions in this period. For instance, altarpieces were part of the standard 'equipment' used for performing the religious rituals associated with the Mass, while drawings were used primarily as means to an end in the process of producing a finished image, rather than preserved as spontaneous traces of a great artist's style or 'hand'. As we shall see in Chapter 3, in the case of frescos, narrative altarpieces, and illuminated manuscripts, artistic skill was deployed to help readers and beholders interpret historical events and make sacred and secular texts generally more memorable. Statues displayed in public spaces, such as those we will discuss in the eighth chapter, were used to glorify the power and potency of both Church and State, while objects such as decorated furnishings, ceramics, tapestries, and metalwork, which we will consider in the seventh chapter, were actively used in the everyday domestic life of wealthy households.

Of course, this does not mean that Renaissance men and women were oblivious to the aesthetic qualities of the things that surrounded them. Indeed, a patron would seek out a famous artist

and pay more for one image or object than another precisely because artistic ability, innovation, and beauty were highly valued. In most cases, however, especially before the 16th century, such considerations remained very much secondary to art's non-aesthetic functions – whether social, devotional, political, or practical – and to the iconography or subject depicted.

Art-making in Renaissance Europe

It is also important for us, as early 21st-century beholders, to keep firmly in mind the very physical, hands-on effort that was involved in actually producing the art that survives from 15th- and 16th-century Europe. Nowadays, when we are used to artists being judged for how innovative, ground-breaking, or even outrageous their ideas and concepts may be, rather than for how skilful or technically proficient they are, it is easy to forget just how much craft and expertise – as well as hard, physical labour – was involved in producing even a small painting on a wooden panel, let alone an entire cycle of frescos on a massive church wall or an over-life-sized statue in solid marble or molten bronze, all in an era before electricity, engines, mass-produced paint and paper, temperature-controlled furnaces, and photography were available.

Imagine how difficult it must have been to hack out by hand the enormous marble block from the mountainside quarries of Carrara that was used for Michelangelo's famous statue of David, a figure that stands more than five metres tall with its base (see Figure 34). After laboriously dislodging the massive block, it had to be dragged down to the Arno River several kilometres away, loaded onto a barge, transported up-river to Florence, and then moved again to a sculptor's workshop with nothing more than donkeys for assistance. Although another artist first started working on this statue, both he and Michelangelo had only hand-powered tools available with which to carve, chisel, and polish the figure. And any work undertaken outside daylight hours would have had to be limited to what could be done safely by candlelight.

Similarly, the hot, sweaty, and often dangerous process of casting a life-size bronze figure is brought home to us by Benvenuto Cellini's mid-16th-century description of the final stages involved in producing his statue of Perseus (see Figure 35):

> Very, very slowly I lowered [the mould] to the bottom of the furnace and filled [it] with a great many blocks of copper and other bronze scraps ... and [began] to melt it down [But soon] the workshop caught fire and we were terrified that the roof might fall in on us and [then] I found that the metal had all curdled As soon as all that terrible confusion was straightened out, there was a sudden explosion and a tremendous flash of fire, as if a thunderbolt had been hurled in our midst When the glare and noise had died away, we ... realized that the cover of the furnace had cracked open and that the bronze was pouring out. [So] I hastily ... drove in two plugs. Then, seeing that the metal was not running as easily as it should, I realized that the alloy must have been consumed in that terrific heat. So I sent for all my pewter plates, bowls, and salvers ... and put them ... into the furnace And then in an instant my mould was filled. So I knelt down and thanked God with all my heart.

Although not quite as dramatic, painting a fresco was also a laborious process that involved producing life-size drawings known as 'cartoons' (from the Italian word for heavy-weight paper, *cartone*) which were transferred onto a thin layer of wet plaster trowelled onto a carefully prepared brick wall. The artist then had to fill in the outline quickly with paint before the plaster dried. The work also had to be done very accurately, since there is no way to 'correct' a fresco by painting over it, given the transparency of the colours, much as is the case with watercolours. Often working well above floor level on rickety scaffolding, without the benefit of electric lights, and forced to hold a paintbrush in an outstretched hand for hours at a time, it is no wonder that even as famous an artist as Michelangelo complained bitterly of having an aching back and neck, not to mention droplets of paint falling into his eyes, while

completing the frescoed ceiling of the Sistine Chapel (see Figure 36). Although popular legend has it that he painted this massive commission while lying on his back, the actual situation, in which he had to stand under damp and dripping paint-covered plaster for literally months on end, seems quite uncomfortable enough.

The preparation of wooden panel paintings such as Domenico Veneziano's *St Lucy Altarpiece*, which were covered with a layer of white plaster-like gesso in order to create a smooth surface on which to apply the traditional egg-based tempera paint, is comparatively much less arduous but still demands a high level of technical expertise (see Figure 3). Beginning in Northern Europe, the growing popularity of oil paints, first used on panels by artists like Jan van Eyck then later on ever-larger linen canvases, made the process of painting and, if necessary, correcting what one had painted somewhat easier, as seen in the size and volume of canvases Titian and his workshop were able to produce by the 16th century (see Figures 18 and 23). Nevertheless, the process of making preparatory drawings without the aid of photographs and the level of skill needed to select wood that wouldn't warp, stretch canvas so it wouldn't sag, and prepare the surface 'ground' of a painting so the hand-mixed tempera and oil paints wouldn't flake or run off is something that those of us used to relying on cameras and the mass-produced materials of uniform quality readily available at our local art supply shop can have difficulty imagining.

Conclusion

While new ideas about 'Art' and the status of the artist did begin to develop during the period, the craft involved in making an image or object, together with its function and iconography, were often valued as much, if not more than, its aesthetic qualities by the patron and original beholders. Renaissance visual and material culture also comprised a balancing act between a sense of

continuity with the artistic traditions of the late Medieval period and a desire to promote innovation through the revival of ideas associated with the Classical world. Many of these inherent tensions are demonstrated particularly clearly in what is perhaps the most important artistic genre of the period, the altarpiece, which is the focus of the following chapter.

Chapter 2
The art of the altarpiece

Altarpieces, old and new

Prior Francesco Ottobon falls asleep in the Venetian church
of Sant'Antonio di Castello while praying to God to protect his
fellow monks from the ravages of the plague. Suddenly, he has
a vivid dream in which ten thousand early Christian martyrs
carrying crosses march into the church to be blessed by St Peter
himself, dressed in full papal regalia (Figure 2). After the
procession finishes, he hears a mysterious voice, which tells
him: 'Do not doubt, remain constant, and I decree that by the
intercession of all of these [martyrs] you will be saved from
the imminent peril.' When, subsequently, none of his colleagues
contract the plague, he asks his nephew to commission a
grand altar with a costly marble frame in thanksgiving for
the martyrs' intervention. The altarpiece's central image,
painted by Vittore Carpaccio, shows the death by crucifixion
endured by these very saints in the Holy Land. The prior must
have asked Carpaccio to make another painting in which
both this new altarpiece, completed in 1515, and his original
vision were depicted in a single composition, as seen in Figure 2.
(The new altarpiece is located under the third arch from
the right.)

This interior view of the church also shows other objects known

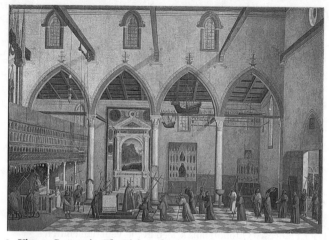

2. Vittore Carpaccio, *The Vision of Prior Ottobon in Sant'Antonio di Castello*, oil on canvas, c. 1515

as ex-votos commissioned by grateful devotees, such as the two model ships that were hung from the rafters by sailors saved at sea after praying for divine assistance. The painting shows as well two additional altarpieces along the church's side wall but it is unclear whether these too were tokens of thanksgiving for past intercessions or pious donations made in anticipation of their patrons' deaths, when prayers would need to be said in order to ensure the future salvation of their souls. Whatever their specific motives, the donors of all three altarpieces did not envision these works merely as static, decorative images to be admired for their aesthetic qualities. Instead, these objects were intended to be actively incorporated into the rituals associated with the Masses celebrated at regular intervals before them, Masses that were often sponsored and underwritten financially by the patrons themselves. In other words, donating an altarpiece also implied donating additional funds to pay for a priest to say a Mass in front of the image on your behalf in perpetuity – or at least until the money ran out.

The painting of Prior Ottobon's vision is of particular interest to art historians because it demonstrates visually the shift that occurred over the course of the 15th century in the design, although not in the function, of altarpieces. While the altarpiece commissioned by the prior's nephew in the early 16th century shows a single, unified narrative scene painted in oil on canvas and housed in an elegant structure evoking Classical architectural forms, the two earlier altarpieces, probably produced in the 14th or early 15th century, are strikingly different. Rather than a single central scene of figures positioned within a naturalistic landscape setting, these works depict instead a number of individual holy figures in full or half length against a gold background, each painted on a separate wooden panel, probably in tempera. And instead of the classicizing geometry of columns, rounded arches, and triangular pediments seen in the later altarpiece's frame, these two earlier polyptychs (so named because they are many-panelled works) set their figures under individual pointed arches similar in shape to those seen in Medieval buildings like the church in which they were originally installed.

Not only did the structure of altarpieces change over the course of the 15th century but the way in which such works were evaluated by their contemporaries changed as well. Although the skill of the artist was clearly important in commissioning and producing the two polyptychs seen in the prior's painting, the patrons and original beholders of these works would probably have been just as impressed by the costly materials that had been deployed, such as the sheets of gold leaf used for the gilding or the precious ultramarine blue made from crushed lapis lazuli imported from the Middle East used on the robes of individual holy figures. Indeed, well into the 15th century, contracts between patrons and artists often specified in great detail what quality and quantity of expensive paint or gold was to be used. But as artists and their patrons became increasingly eager to depict figures and settings more naturalistically, the use of gilded backgrounds began to look more and more old-fashioned. At the same time, the very abilities needed

to paint figures and backgrounds in a convincingly naturalistic way, combined with a growing interest in stylistic and compositional innovation for its own sake, meant that artistic skill and ingenuity began to be increasingly valued by more progressive patrons over and above the cost of the materials actually used.

The early 15th-century Florentine architect, sculptor, and art theorist Leon Battista Alberti clearly articulates this gradual shift from material to artistic values:

> There are painters who use much gold in their pictures because they think it gives them majesty: I do not praise this. Even if you were painting Virgil's Dido – with her gold quiver, her golden hair fastened with a gold clasp . . . and all her horse's trappings of gold – even then I would not want you to use any gold, because to represent the glitter of gold with plain colours brings the craftsman more admiration and praise.

The artists Alberti most admired did, in fact, use 'plain colours' alone to represent the natural world and human anatomy with increasing precision, as well as to depict buildings and architectural spaces in a convincingly three-dimensional manner, as we shall discuss at greater length in the fourth chapter.

The altarpiece in Italy

One interesting early example of the new style of painted altarpiece is the panel made by Domenico Veneziano in c. 1445–7 for the Florentine church of S. Lucia dei Magnoli, probably to replace an older multi-panelled work with a gilded background (Figure 3). Although the composition's three-bayed architectural structure still echoes older arched, three-panelled triptychs, the artist has clearly sought to present beholders with a single, spatially unified scene that seems to be a continuation of the space in which we ourselves stand. The link between image and beholder is further heightened by the outward gaze and pointing gesture of the second

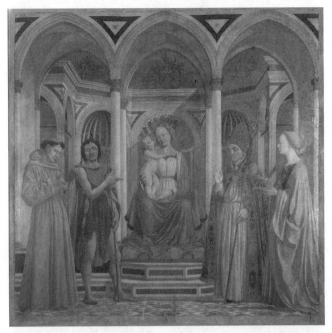

3. Domenico Veneziano, *St Lucy Altarpiece*, tempera on panel, c. 1445–7

figure from the left, John the Baptist, who seems to invite us in personally to worship the Madonna and Child appearing before our eyes.

The architectural space depicted in Giovanni Bellini's *San Giobbe Altarpiece* (Figure 4), painted before 1478, is even more convincing. The work was commissioned to fulfil the demands, devotional as well as social, of its patrons, who were members of the Confraternity of San Giobbe (St Job), a kind of charitable organization and social 'club' for well-to-do Venetian citizens. Rather than employing real gold leaf, Bellini used only the 'plain colours' advocated by Alberti (albeit relying on shimmering oil paint rather than the much more matte tempera used in the *St Lucy*

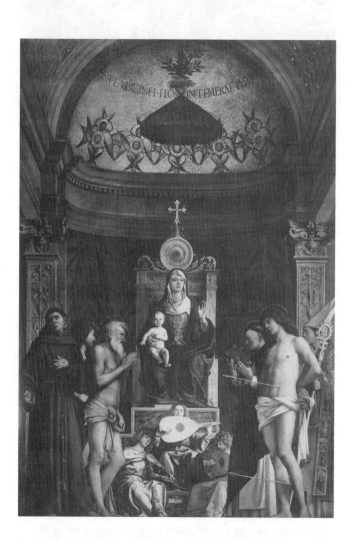

4. Giovanni Bellini, *San Giobbe Altarpiece*, oil on panel, before 1478

Altarpiece) to depict the glittering half-dome of what appears to be a fully three-dimensional chapel. Indeed, Bellini is so consistent in producing this illusion that he even includes a hanging lamp in the upper section of the composition, depicted as if submerged in dark shadows while apparently dangling between our space and the fictive chapel, which is lit by a mysterious divine light.

One explanation as to why Bellini came up with this innovative design lies in the architectural situation of the Venetian church of San Giobbe in which the painting was originally hung along one of the nave's walls. Thanks to a canal running along one side, the church could not have accommodated an actual three-dimensional chapel on this side of the building. But, in any case, no real chapel could have allowed the artist to link the world of his patrons with the visionary world depicted in the altarpiece so successfully. Here, in a heavenly apparition that seems to be a seamless extension of our own space, we see the Madonna solemnly raising her hand to bless the devotees gathered before the altar, with the nearly nude figure of St Job on the left interceding with clasped hands on our behalf, and the sympathetic figure of St Francis (whose order, the Franciscans, were in charge of the church) on the far left reaching down with his outstretched hand as if to invite us individually to join the holy gathering.

In Raphael's *Sistine Madonna*, which we encountered in the first chapter, the illusion is not of the Virgin appearing to us as if in an actual chapel, but rather of curtains being drawn aside from an enormous window, through which we see St Mary coming down from Heaven to present her precious Child to us (see Figure 1). Once again, however, one of her saintly sidekicks gestures outwards as if inviting the beholder to enter the scene. The gesture is particularly significant once one realizes that the bearded figure who makes it is St Sixtus, patron saint of Pope Sixtus IV, the deceased uncle of the then pope, Julius II, the man probably responsible for commissioning this work for the high altar of a

convent of Sistine nuns in the Italian city of Piacenza. The delightful angels at the bottom of the composition, who lean on a window ledge that seems to exist somewhere between our space and the heavenly realm depicted in the painting, thus serve a specific devotional function: they help to bridge the gap between this world and the next, thereby allowing the prayers of the nuns for whom the image was originally made to entreat the Virgin more directly on behalf of the dead pontiff's soul. Thus, although the angels are clearly beautiful beings well suited for our aesthetic contemplation in the Dresden gallery where the painting hangs today, it is only by setting them into their original context and trying to see them through the 'period eye' of their original beholders that the non-, or better, extra-aesthetic aspects of the composition become apparent.

Carved and painted altarpieces in the North

An interest in using innovative visual means to enhance the long-standing devotional, social, and even occasionally political functions of altarpieces can also be seen in works produced by artists in Northern Europe. In the 15th and early 16th centuries, artists and patrons in Germany and the Low Countries began to develop new visual and iconographic strategies, while at the same time maintaining traditional altarpiece formats that had their origins in the Middle Ages. So, rather than a shift from polyptychs to altarpieces with a single, central painted scene, as was the case in Italy, artists such as Matthias Grünewald in the *Isenheim Altarpiece* of c. 1513–15 and Tilman Riemenschneider in the *Altar of the Holy Blood* of c. 1499–1505 continued to use the Medieval winged retable altarpiece as their basic structural unit. The retable (which comes from the Latin for 'behind the [altar] table'), which could be painted or sculpted, consisted of a central group of individual figures or, later, a single image, in either case flanked by shutter-like wings on each side that usually could be closed, to protect the interior section, or opened on special religious feast days.

While the structures of these altarpieces broadly recall those of their

Medieval predecessors, the fact that they sought increasingly to be more physically and psychologically convincing and began to favour unified pictorial fields instead of individually displayed saints has obvious parallels with developments in Italy. In the case of the *Isenheim Altarpiece*, while the innermost central core still consists of individual gilded statues of saints displayed within an elaborate, Gothic-style framework, the three sets of wings and two sets of central panels that cover and surround these figures are very different in both style and spirit (Figure 5). In these panels, oil paints are used to depict key intercessory figures (including the Madonna), the resurrected Christ, and, in the central panel of the outermost 'layer' of the altarpiece, an astonishingly gruesome Crucifixion scene. Here, Christ's body is covered in oozing, pus-filled lacerations, his cracked lips painted in the dry bluish-white of the dead. However, this shockingly naturalistic image would probably not have seemed out of place to the work's original beholders. These were desperately sick pilgrims who had travelled to Isenheim (in the Alsace region, located around the present-day Franco-German border) to seek a miraculous cure for an excruciatingly painful and deforming fungal disease known as 'St Anthony's Fire', which made victims' limbs turn black and green with gangrene before eventually falling off. For such beholders, seeing the dead Christ portrayed in horrifying detail would have perhaps suggested that their Saviour could empathize with their sufferings and that, like Jesus, they too would one day be resurrected into perfect, whole, and healthy bodies.

Rather than using the highly descriptive medium of oil paint, Reimenschneider's *Altar of the Holy Blood* in the southern German city of Rothenburg engaged its beholders by exploiting the particular qualities of limewood as a medium and by playing with the lighting possibilities of the Church of St Jakob in which the work still stands to this day (Figure 6). Unlike the brightly painted carved retables of his predecessors and, indeed, many of his contemporaries, the wooden figures and reliefs in

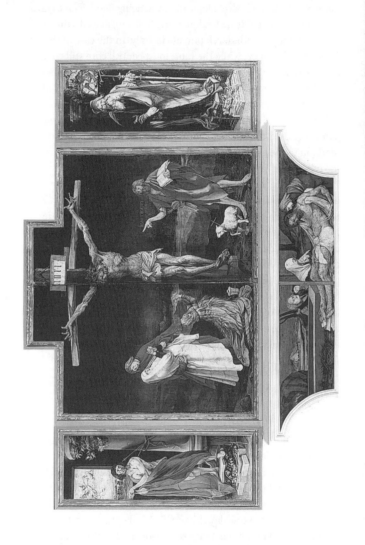

Reimenschneider's Rothenburg altarpiece were painted just in translucent brown glazes, with the only exceptions to the overall monochromatic scheme being dots of black paint on the figures' pupils and dabs of pale red glaze on their lips. Like Grünewald's outermost central panel, the central section of this work also focuses on a single, unified narrative scene, in this case a three-dimensional rendering of the Last Supper, with the figure of Judas in the middle caught in the act of betraying Christ. By avoiding the thick gesso undercoating that normally had to be used when painting wooden figures in bright colours, Reimenschneider was able to make the most of limewood's relative softness and pliability by carving much finer and more psychologically convincing details than could have been seen under a thick layer of opaque paint. He further enhanced the scene's dramatic impact by using roundels of thick, clear glass behind the *Last Supper* rather than having a solid wooden back wall as was usually the case, thereby allowing the natural light from the tall windows behind the altar to become an active and ever-changing component of the narrative scene.

In addition to the *Last Supper* in the centre, the altarpiece also originally housed in its lower section the town's most precious sacred relic, believed to be a drop of Christ's own blood. Of course, it was at the Last Supper that Christ had instituted the celebration of the Eucharist, which included having the apostles drink his blood-as-wine. The subject chosen for the central section of the retable was thus most appropriate for the altar's reliquary functions, which would have been uppermost in the minds of the work's patrons, the town councillors of Rothenburg. The innovative visual and material strategies developed by Riemenschneider in this work were thus once again deployed in the service of his patrons' needs, rather than primarily to fulfil an abstract aesthetic brief.

5. **Matthias Grünewald,** *The Isenheim Altarpiece*: **(left to right)** *St Sebastian, The Crucifixion, St Anthony Abbot,* **and (below)** *The Lamentation over the Dead Christ,* **oil on panel, c. 1513–15**

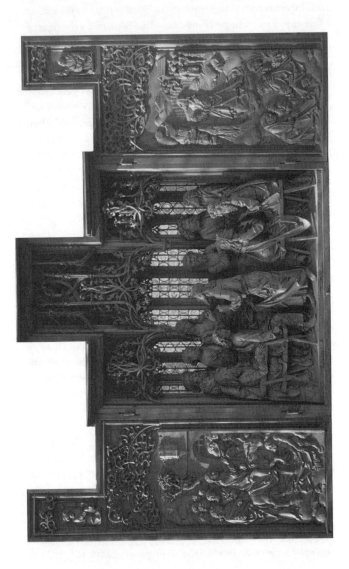

Indeed, it is significant that the carpenter who made the shrine-like structure that housed Riemenschneider's carvings was initially supposed to be paid 50 florins, exactly the same amount as the sculptor himself. Only after the altar had been completed did the latter's fee increase to 60 florins, thanks to a special bonus payment given for a job well done. But the fact that 'mere' carpentry was valued nearly as highly as an object that we would today consider a work of art is very revealing. Indeed, this payment scale confirms that the councillors' first priority was to produce an attractive and functional devotional complex that would enhance their city's reputation and entice more pilgrim-tourists – and their spending power – to Rothenburg to worship their prize relic. Seen in this light, it makes perfect sense that the patrons were as keen to ensure that the town's key attraction was properly 'packaged' in a wooden shrine as they were to commission moving and aesthetically pleasing sculptures for the interior sections of the altar.

Making and meaning in Raphael's *Entombment*

The way in which the innovative formal and iconographic strategies deployed in such pre-Reformation altarpieces could be combined with the genre's long-standing devotional and social functions is also highlighted by the final work we will consider in this chapter, Raphael's *Entombment of Christ* of 1507 (Figure 7). On a formal level, this painting displays the artist's extremely sophisticated compositional skills and his ability to incorporate almost effortlessly visual references to antique sources, such as Roman sarcophagi reliefs depicting the dead hero Meleager being carried away for burial. At the same time, the story of its making demonstrates the wide range of devotional, personal, and even political meanings that could be embedded in a single Renaissance altarpiece, aspects that are often lost when such a work is seen on a gallery wall, far removed from its original context.

6. Tilman Riemenschneider, *Altar of the Holy Blood*, brown-glazed limewood, c. 1499–1505

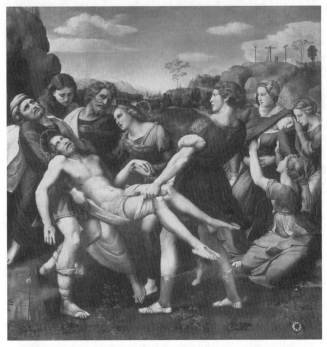

7. Raphael Sanzio, *The Entombment of Christ*, oil on panel, 1507

The altarpiece was commissioned by a noblewoman, Atalanta
Baglioni of Perugia. Atalanta had been widowed at a relatively
young age and, having never remarried, she had become the head of
her household. Significantly, this meant that she was now in charge
of the family's wealth and income, an unusual situation for a
woman in this period, but one that would have allowed her to
decide independently to hire the ambitious young artist. At the time
of Atalanta's commission, Perugia was a city of violence: not only
did the town engage in military skirmishes with its neighbours, but
inside its walls, its powerful ruling clans were frequently involved
in bloody feuds with rival families. In the case of the Baglioni,
the fights were not just with other families, but also amongst
themselves. One of the most notorious incidents involved Atalanta's

son, Grifonetto, who in 1500 had tried to murder all his senior male relatives during a family wedding feast. A number of kinsmen were killed but those who survived the carnage vowed revenge on the young upstart. Grifonetto managed to escape but only after his mother had refused to grant him protection inside her own house. When Grifonetto returned to Perugia, planning to beg his relatives for forgiveness, he was instead immediately stabbed repeatedly by one of his aggrieved kinsmen. Atalanta rushed down to her dying son but, rather than giving him any motherly comfort, she instead coldly ordered him to forgive his assassins, thus demonstrating very publicly that she was willing to put family honour ahead of maternal instinct.

However, a few years later, Atalanta decided that something had to be done to try to redeem the memory of her dead son and, perhaps, to try to atone for her own rather heartless behaviour in his moment of need. So, she decided to ask Raphael, who had worked for several years in Perugia before moving to Florence, to return to the city in order to paint a splendid new altarpiece on her behalf. Rather than depicting a group of static standing saints, however, Atalanta's altarpiece showed a poignant narrative scene of the dead Christ surrounded by mourners and about to be carried away to his grave. Here, in Raphael's visually complex image, with gracefully intertwined figures moving rhythmically across the front plane of the picture like a Classical relief scene, the tragic death of a son is finally mourned by a mother. Indeed, the Virgin Mary is shown collapsing dramatically under the intolerable weight of her grief on the far right side of the picture, perhaps a way for Atalanta to atone visually for her emotionally restrained public response to her own child's demise seven years earlier. The altarpiece would, in any case, have served as the visual focus for the commemorative Masses Atalanta would have arranged to be said in perpetuity for the soul of her son – and, implicitly, for her own future salvation as well.

Raphael's skill and ingenuity in creating such a moving image were obviously crucial to its success. Indeed, it is likely that, in this work,

Raphael had sought to supercede artistically both his presumed teacher, the local painter Perugino, who had produced an altarpiece with a very similar subject a dozen years before, and his own earlier works, including an altarpiece painted in Perugia for female members of the Oddi family, great rivals of the Baglioni. But, ultimately, as we have seen in many of the other examples considered in this chapter, Raphael's undoubted artistic abilities were deployed first and foremost in the *Entombment* to fulfil the demands of his patron, not the demands of 'Art' in our present-day understanding of the word. Seen in their original contexts, therefore, such altarpieces were much more than just pretty pictures; instead, they were the visual and material embodiments of complex webs of devotional, social, and even political demands that the most successful artists of the 15th and early 16th centuries would have sought to fulfil in new and ever more innovative ways.

Conclusion: sacred images and iconoclasm

The altarpiece tradition, with its roots in Medieval polyptychs and winged retables, continued throughout the 16th century and beyond in Italy, France, Spain, and the Catholic areas of Northern Europe. But the tradition came to an abrupt, even violent, end in towns and regions engulfed by the flames of the Protestant Reformation from the early 16th century onwards. Reformers such as Martin Luther, after carefully considering the Biblical commandment explicitly forbidding the making of 'graven images' (Exodus 20: 4–5), began to argue that pictures of holy figures and sacred stories had no place in churches and, possibly, even in the private devotional practices of believers. Such ideas were given further support by the long history of very real abuses associated with religious paintings and statues that, despite repeated warnings issued over the centuries, had often in practice been worshipped and adored as though they were themselves holy, rather than merely representations of the divine. While some Reformers did allow certain types of religious images to continue to be used in strictly limited ways as aids to devotion, others not only forbade the making

of any new religious artworks but actually sought systematically to destroy all existing sacred statues and paintings, with altarpieces a particular focus of their fury. In 1566, a British witness described one such act of devastation in the Cathedral of Antwerp, one of the main towns in the Southern Netherlands, in what is known today as Belgium:

> I went into the church It looked like a hell, as if heaven and earth had gone together, with falling images and beating down of costly works ... all, destroyed! [It was] the costliest church in Europe; and they have so spoiled it, that they have not left a place to sit on in the church.

Such virulent iconoclasm, which occurred from the third decade of the 16th century onwards in different parts of Northern Europe, according to local religious but also political circumstances, not only resulted in the wholesale destruction of literally centuries of religious art of all types, including innumerable altarpieces, but also severely reduced the working opportunities for artists who had previously relied so extensively on lavish altarpiece commissions for their livelihoods. In the Protestant North after about 1520, art-making was not a particularly good career choice unless one was willing to concentrate on generally smaller-scale and thus less well remunerated secular genres such as portraiture, as we shall see in Chapter 5. But for painters and sculptors working in Catholic lands, the altarpiece tradition would continue triumphantly for centuries to come.

Chapter 3
Story-telling in Renaissance art

Ursula's tale: a very Venetian story

In Britain was a Christian king . . . [with] a daughter named Ursula.
This daughter shone full of marvellous honesty, wisdom, and beauty
. . . . And the King of England [who still worshipped pagan idols] . . .
said that he would be well happy if this virgin might be coupled to
his son by marriage. And the young man had great desire and will to
have her. And there was a solemn embassy [sent] to the father of
Ursula, and promised great promises, and said many fair words for
to have her And she, that was divinely inspired, did consent . . .
to the marriage [on the] . . . condition: that . . . the young man
should be baptized [and allow her to go on pilgrimage accompanied
by 11,000 virgins. The prince] . . . commanded all that Ursula had
required should be done [and so] they went towards Rome.

Thus began the tale of St Ursula in the *Golden Legend*, a collection
of sacred stories compiled by a 13th-century archbishop of Genoa,
Jacopo da Voragine. The book was hugely popular throughout
Europe, perhaps almost as readily available as the Bible itself. By
1500, nearly 75 Latin editions had been printed, not to mention
several more in English, Italian, French, German, and Bohemian. It
would therefore have been quite easy for the Venetian confraternity
known as the Scuola di Sant'Orsola to track down a detailed
description of the legendary life of their patron saint, Ursula, when

they decided to commission a new set of paintings for their clubhouse to replace some old, worn-out frescos.

In 1488, the confraternity, which included men as well as women and true patricians as well as the merely well-off, hired a young, up-and-coming artist named Vittore Carpaccio, whom we have already encountered in the previous chapter, to illustrate the story of St Ursula in a series of large canvases approximately three metres high and up to six metres long. These paintings, executed between 1490 and 1500, were hung all around the interior of the building that served as both the confraternity's meeting house and its communal chapel. They depicted the life of St Ursula in a slowly unfolding narrative sequence, beginning with the embassy sent by the King of England to bid for the beautiful Christian princess's hand in marriage for his son (Figure 8).

In this canvas, we see in the distance the ship from which the ambassadors have disembarked moored at the far end of a grand square. At the front of the picture plane in the central section of the canvas, the ambassadors themselves are shown in a ceremonial procession that unfolds across the painted surface from left to right. The figures are depicted almost as if in a sequence of still frames from a film: first, just peeking out from the second column from the left, we see two figures standing; then two more figures seem to be in the process of kneeling down; while the next two figures are shown on fully bended knees before the enthroned king. The sense of an almost cinematic progression in time and space continues in the far right scene of the canvas, in which the beautiful young saint is shown standing in a much more private space with a richly canopied bed, discussing the marriage proposal with her world-weary father, his head resting in the palm of his upturned hand. It is here, at this point in the tale, that Ursula makes the fateful, albeit 'divinely inspired', decision to ask her suitor to convert to Christianity and allow her to go on a pilgrimage to Rome with a retinue of 11,000 virgin women. In the narrative canvases that

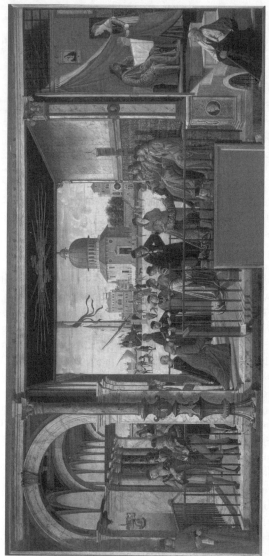

8. Vittore Carpaccio, scenes from *The Legend of St Ursula: Arrival of the English Ambassadors and St Ursula with her Father*, oil on canvas, 1490s

follow, we see the ambassadors' departure, followed by the princess bidding farewell to her fiancé, travelling to Rome to meet the pope, and then, tragically, being murdered (and thus martyred), together with all her female companions, on the trip back to England by a pagan horde of Huns.

Despite the dramatic possibilities of the story, the visual emphasis in many of Carpaccio's canvases is often on the tale's ceremonial moments, with figures processing to and fro or being officially greeted by kings, popes, and princes. The stress laid on such ritual behaviour would have reflected the ceremonies and rituals in which the confraternity's members themselves were regularly engaged. For instance, once a month, the entire membership of the Scuola di Sant'Orsola would gather in the meeting house to celebrate a Mass together, an event that would kick off with each member holding a candle in his or her hands while processing around the perimeter of the room. In fact, this monthly procession would very much have echoed the painted processions depicted on the canvases displayed on the walls of the chapel-clubhouse. In many of the canvases, the artist has used a variety of other visual strategies to further break down the boundaries between actual beholders and Ursula's fictive world. In the canvas depicting the arrival of the ambassadors, for instance, a space is left open in the balustrade at the front of the picture plane as if to allow us to join the English delegation, while on the right of the canvas, a staircase guarded only by an elderly female servant seems to invite us into the bedroom where Ursula and her father are having their heart-to-heart discussion. Likewise, just beyond the metal railing separating the ambassadors from the enormous public square, we see a row of local spectators leaning on the fence while looking at the events in progress with great fascination – much as we, also separated from part of the scene by a railing, do as well. In other words, the spectators inside the scene on some level seem to mirror the beholders standing in front of the canvas.

On the days around the annual feast of St Ursula on the 21st of

October, the confraternity's members would themselves have been on public view, with processions and other festivities in honour of their patron saint taking place not only inside their meeting house, but also outside on the public square in front of the building, where fellow Venetian citizens would have observed their rituals and ceremonies at first hand. Carpaccio's canvases thus told tales that would have had a very direct relevance for the men and women who had commissioned them, tales with a visual narrative structure that in many cases mirrored the actual ceremonial structure of the confraternity's own rituals. At the same time, these rituals and the images commissioned by the Scuola di Sant'Orsola straddled the sacred-secular divide, much like the confraternity itself, which was both a religious and a social organization. This is reflected in the fact that the story of St Ursula not only emphasized religious themes such as devotion to one's faith even in the face of martyrdom or the enticing proposals of a pagan king, but also echoed the social rituals of Venetian ceremonial life and, with its images of ships sailing to and from distant lands, recalled the international trade upon which Venice's economic and political life depended.

Narrative images: sacred or secular?

In many other examples, it can be equally difficult to decide categorically whether the stories told by Renaissance artists in their works should be tied exclusively to either the sacred or secular realm. For instance, the *St Lucy Altarpiece*, which we considered briefly in the previous chapter, originally had small narrative images known as predella panels positioned directly beneath each of the figures in the main scene (see Figure 3). At first glance, these pictures, which depict a significant episode in the life of each saint standing above, might seem to be purely religious paintings. However, the fact that two of these depicted key events in the lives of Florence's most important patron saints, John the Baptist and Bishop Zenobius (both also depicted in the main scene), suggests that the person who commissioned the altarpiece might well have

wanted to demonstrate political loyalty to his home town as well as make evident his religious sentiments. In the case of Raphael's *Entombment*, the sacred narrative of the main panel was as much a product of Atalanta Baglioni's complicated personal and political concerns as it was intended to serve as the focus for pious devotion during the Mass (see Figure 7). Likewise, an early 16th-century collector buying the set of 17 woodcuts illustrating the *Life of the Virgin* by Dürer would have appreciated these images not only for their devotional efficacy in telling a sacred narrative, but also for the fact that their beautiful compositions had been devised by one of Northern Europe's most highly esteemed artists.

A similar tension between the secular and the religious can be seen in hand-copied illuminated prayer books known as 'books of hours', an art form dating back to Medieval times but still very much alive in the Renaissance, even well after Johannes Gutenberg had invented the modern printing press in the mid-15th century. Although books of hours were used within the private devotional practices of devout believers, they were also fantastically expensive luxury items hand-crafted with precious pigments and gold leaf on sheets of vellum made from animal hides. Not surprisingly, only the very rich could afford such objects, and thus these books inevitably attested to their owners' wealth, taste, and prestige as much as to their piety. A particularly fine example of such a book is the one commissioned for Mary, Duchess of Burgundy, in about 1480. The frontispiece, or first illustrated page, shows the duchess herself reading an illuminated manuscript very much like the one that had been made for her (Figure 9). Beyond her seated figure, through an open window, we see the duchess depicted once again, this time attended by ladies in waiting in a vast church and kneeling before her namesake saint, the Virgin Mary. The picture within the painting is presumably meant to make visible the other-worldly scene that would have been conjured up in Mary's own mind after reading the religious tales and reciting the prayers found in her book of hours.

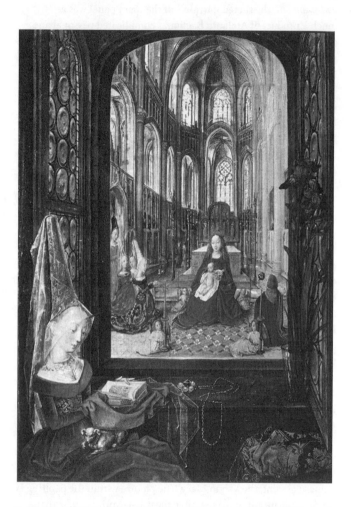

9. Master of Mary of Burgundy, *Mary of Burgundy Reading a Book of Hours, with a Vision of the Madonna and Child in a Church*, illumination on parchment, c. 1480

While it is highly likely that she was a genuinely devout woman, the expense and effort involved in hand-copying and painstakingly illustrating such a work in the first place would have made a very clear statement about her social, political, and economic status in the present world – something further emphasized by the enormous jewels lying casually on the windowsill and the luxurious velvets, silks, and brocades worn by Mary and her attendants in this image.

Of course, as we saw in the previous chapter, one could argue that it was sacrilegious to make a concrete image of any religious story or sacred figure given that the Ten Commandments explicitly forbade the production of 'graven images' of any kind and, especially, the veneration of such images. Already in the 7th century, however, Pope Gregory the Great had decreed that religious images could be made (although not actually worshipped) in order to enlighten the illiterate. Looking at images was also considered a more efficacious means of remembering scripture and being moved by sacred narratives than was the case for the spoken or written word alone. These arguments in favour of religious pictures were summed up in 1492 by Michele da Carcano, a Dominican friar:

> ... images of the Virgin and Saints were introduced for three reasons. *First*, on account of the ignorance of the simple people, so that those who are not able to read the scriptures can yet learn by seeing the sacraments of our salvation and faith in pictures *Second*, images were introduced on account of our emotional sluggishness; so that men who are not aroused to devotion when they hear the histories of the Saints may at least be moved when they see them ... in pictures. *Third*, they were introduced on account of our unreliable memories because many people cannot retain in their memories what they hear, but they do remember if they see images.

A fresco cycle in Florence

One of the most publicly accessible depictions of sacred narratives
were the large-scale fresco cycles that had been painted on the
walls, domes, and ceilings of churches and chapels for centuries. In
the Renaissance, this practice continued, with new visual strategies
such as linear perspective and the use of increasingly accurate
depictions of human anatomy deployed to make the stories ever
more vivid and convincing. For instance, in the Florentine church of
S. Trìnita, we see key scenes from the life and afterlife of St Francis
depicted on the walls of one of the chapels (Figure 10). At first
glance, these images painted by Domenico Ghirlandaio and his
assistants in the mid-1480s seem perfectly designed to fulfil the
devotional requirements of 'legitimate' religious images: by
portraying significant events associated with St Francis and
situating some of the scenes in contemporary Florentine settings,
the frescos would have made the stories depicted accessible to
those who could not read and particularly memorable and moving
to all and sundry.

The story of Francis and the miracles he was believed to have
performed after his death are depicted in chronologically
consecutive circles going from top to bottom. So, on the uppermost
level of the chapel's walls, we see (moving clockwise) the young
Francis renouncing his inheritance in order to lead a life of holy
poverty, the Pope officially approving the new Franciscan order he
had founded, and Francis miraculously surviving a trial by fire while
visiting a sultan's court. On the middle level, Francis is shown
receiving the *stigmata* (that is, having the wounds of Christ appear
on his own body) on the left wall, and his funeral is depicted on the
right wall, while in the centre we see the miraculous resurrection of
a dead child after prayers were addressed to the deceased saint.

10. Sassetti Chapel: Domenico del Ghirlandaio and assistants, *Life
of St Francis* fresco cycle and copy of *Adoration of the Shepherds*
altarpiece, and Giuliano da Sangallo (attr.), black marble tombs of
Francesco Sassetti and Nera Corsi (in niches on side walls), 1483–6

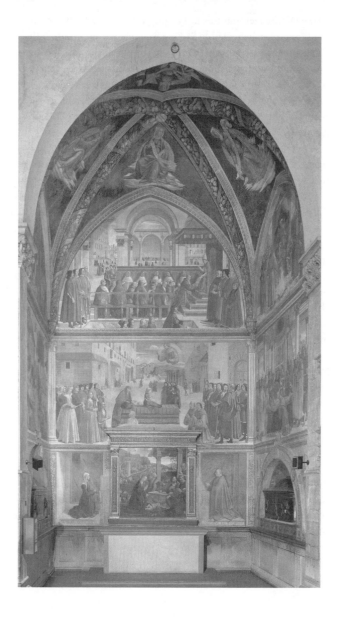

However, the fact that this last event, which is hardly ever seen in other cycles dedicated to St Francis, is shown so prominently above the chapel's altarpiece and slightly out of chronological order (that is, this posthumous miracle is depicted before the scene of the saint's funeral on the right wall) suggests that the chapel was perhaps not made exclusively to transmit accurately and vividly key aspects of a holy narrative to illiterate devotees.

Instead, this scene and the entire lower level of the chapel confirm that something other than pure piety was involved in this project. For it is here, at the level closest to the visitor to the chapel, and in the prominently placed frescos set directly above the altarpiece, that the demands of the patron, Francesco Sassetti, become evident. Sassetti was the general manager of the Medici family bank and thus his fortunes were closely tied to the financial and political success of this powerful Florentine clan. Not only did he choose to make his namesake saint, Francis, the main subject of his family chapel's frescos, but he also made sure that his Medici bosses and their allies were favourably represented as well, specifically, by including their individual portraits in the two central wall's main frescos. In the uppermost fresco, the head of the family, Lorenzo de' Medici, is shown standing by Francesco in a setting clearly intended to recall Florence's main townhall square. The next scene down, in which a child is miraculously resurrected, is also set in Florence, this time in the square in front of the church of S. Trìnita itself. Given that Francesco's own eldest son had died at the time that Ghirlandaio began designing the fresco cycle, with another male child miraculously born just a few months later, it is likely that an image of a resurrected boy set above an altarpiece depicting the Nativity of Christ (also painted by Ghirlandaio) might have been an act of thanksgiving on the patron's part for the birth of his new son. Indeed, it has even been suggested that the resurrected boy is actually a portrait of Francesco's youngest son.

Finally, just to make the personal motivations absolutely clear,

Francesco not only installed black marble tombs (possibly made by the sculptor Giuliano da Sangallo) with classicizing motifs for himself and his wife, Nera Corsi, in the two niches on the left and right lower level of the chapel, but he also had himself and his spouse depicted kneeling in prayer on either side of the altar, participant-witnesses at the Nativity portrayed in the altarpiece and at all the Masses said on behalf of their souls at the altar itself. So, while prayer and piety were certainly important motives for commissioning the fresco cycle, enlightened self-interest both in this world and the next played an important part as well. The story told here, in other words, was as much Francesco's as St Francis's.

More story-telling strategies

The practice of depicting a sacred story while at the same time commemorating, or even glorifying, a patron is also evident in the sculptor Guido Mazzoni's *Lamentation*, a life-size, three-dimensional tableau of painted terracotta figures of grieving mourners surrounding the dead body of Christ (Figure 11). The group was completed in the early 1490s and installed in the Church of Sant'Anna dei Lombardi in Naples. Here, the beholder is literally able to enter into the sacred narrative that is enacted by fully in-the-round sculpted beings. Significantly, however, one of the mourners, the man kneeling at the far left, and thus closest to the visitor as he or she approaches this three-dimensional tableau, is a portrait of the project's patron, King Alfonso II of Naples. Not only was Alfonso trying to guarantee his spiritual salvation by being depicted for all eternity in perpetual prayer and adoration before Christ, but such an ensemble, originally installed in his own family chapel, and a project in which he was not just a witness but an actual participant in the sacred drama, would clearly have enhanced his personal and political reputation as well. Once again, a personalized sacred narrative seems to have been deployed to smooth the way for a patron both in this world and the next.

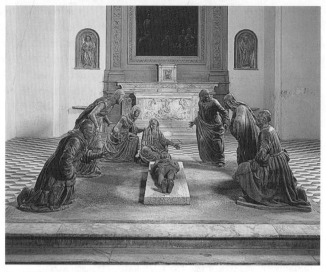

11. Guido Mazzoni, *The Lamentation over the Dead Christ*, painted terracotta, 1492–4

Although the lack of a clearly demarcated division between the holy and the profane in such projects can seem somewhat confusing to present-day viewers, Renaissance patrons, artists, and beholders might not have felt obliged to make such distinctions in the first place, seeing instead a continuum between the sacred and the secular. Nevertheless, some stories told by Renaissance artists were clearly of a purely secular nature, with no discernible hint of religious piety to muddy the waters from our point of view. In these cases, however, the tales told were once again designed to enhance the reputation of the person who had commissioned them. This can be seen in the mythological and allegorical images commissioned by the French king François I for his château, or country palace, in Fontainebleau, not far from Paris. Here, employing mainly artists imported from Italy, such as Rosso Fiorentino and Primaticcio, the king sought to baffle and amaze elite visitors though the use of complex visual iconographies for the elegant paintings that were set within elaborate, highly mannered stucco frames and displayed in

12. Giovanni Battista Rosso Fiorentino, *Danae visited by Jupiter disguised as a Shower of Gold*, fresco with surrounding stucco reliefs, 1530s

the château's main public rooms and galleries. Only the king himself was fully apprised of the precise meaning of each painting. In fact, the 'narrative' aspects of these works were not just found in the stories depicted within the paintings, but also enacted in the guided tours or, better, performances given by the king himself for his visitors, as he elucidated each picture's significance to the amazement of the onlookers. One of the more straightforward tales depicted was that of Danae, the beautiful girl impregnated by the pagan god Zeus who had appeared to her in a cloud of golden rain (Figure 12). But the exact iconographic significance of other images commissioned by François are still the subject of scholarly debate to this day.

Conclusion

Renaissance art, whether sacred, secular, or somewhere in between, was full of stories. Indeed, one of the primary functions of art in general in this period was to communicate stories and ideas by visual means to contemporary beholders in ways that were often more enticing, vivid, and memorable than was possible in a text, sermon, or speech alone. As Alberti put it in the 1430s, the most successful visual narrative, or *istoria*, was one that was 'so agreeably and pleasantly attractive that it will capture the eye of whatever learned or unlearned person is looking at it and will move his soul'. In the public realm, narrative altarpieces (both painted and sculpted in three dimensions), predella panels depicting saints' lives, paintings for confraternities, grand fresco cycles in churches, and Classically inspired palace decorations not only helped beholders remember particular stories through their attractive imagery, but also inevitably reflected the personal, political, and social agendas of the people or organizations that had commissioned them. Sometimes, as in the case of illuminated manuscripts or a set of narrative prints, story-telling could be a more private, even intimate, activity involving just one person holding a book or sheet of paper in his or her hands. But even in such instances, how a particular story was told pictorially, and how it was interpreted, depended very much on the interests, beliefs, and priorities of the patron and his or her contemporary beholders.

Chapter 4
The challenge of nature and the antique

Fictive flies

We see before us a portrait of a well-to-do husband and
wife posing behind a table-ledge on which a variety of meticulously
depicted objects are displayed (Figure 13). On the lower edge
of the frame, the date 1496 is visible, along with the ages of
the couple, indicating that he was 36 and she 27 when the image
was completed. The coat of arms at the top of the composition,
cradled by a bull, symbol of the Evangelist Luke, was associated
with the Antwerp painters' Guild of St Luke, as were the delicate
buds, known as stock-gillyflowers, displayed in the vase and
held in the woman's hand. This, combined with the male
sitter's direct outward gaze, has suggested to many scholars
that the panel may, in fact, be a self-portrait of a painter with
his wife. Interestingly enough, if the artist had been looking
into a mirror while painting this work with his right hand, it
would be this hand that would correspond to the one hidden
beneath the ledge in the picture, a common strategy in artists'
self-portraits given that it is very difficult indeed to depict one's
own hand while it is in use.

The artist usually linked with the painting on stylistic grounds is the
Master of Frankfurt, so called because one of the most important
works associated with this figure was made for a church in that city.

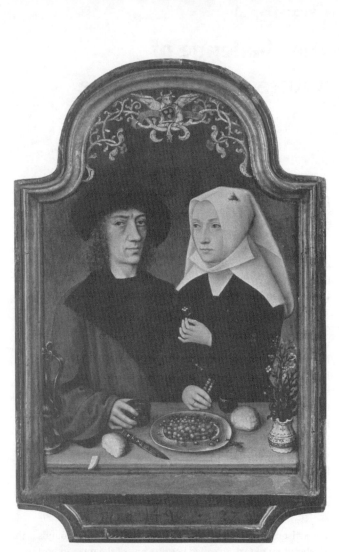

13. Master of Frankfurt (active in Antwerp; possibly Hendrik van Wueluwe?), *Portrait of an Artist and His Wife*, oil on panel, 1496

However, from the coat of arms and the general style of the painting, it is highly likely that the artist was actually based in Antwerp. Documentary evidence suggests that this anonymous painter may, in fact, have been one of the most active and prominent artists in Antwerp in the first decades of the 16th century, one Hendrik van Wueluwe, who, among other positions, served as dean of the Guild of St Luke for an unprecedented six terms of office and who, in the same year in which this portrait was painted, was recorded as buying a stone house and marrying Heylwich Thonis, daughter of a fellow artist who had also served as dean of the guild.

Art historians have tended to focus on trying to confirm the painter's identity and to decipher the symbolic meanings of the various objects depicted. For instance, some observers have linked the cherries (known as the 'fruit of paradise') scattered on the centrally placed plate to the iconography of the Virgin Mary, the mystical bride and mother of Christ and thus a most appropriate model for a newly wed wife. Indeed, the fairly intimate pose of the couple, along with the tantalizing fact that van Wueluwe was married in 1496, has led to the suggestion that this painting may have been made to commemorate the couple's marriage. The fact that hunks of bread and a cup of wine, symbols of the Eucharistic rituals associated with the Mass, are prominently displayed enhances the sense that solemn vows have been exchanged and implies that this image may have been intended as a visual guarantee that God's blessing had indeed been bestowed upon the new couple.

But suddenly, we realize that something has unexpectedly disturbed this perfect vision of marital peace and prosperity: on the pure white painted surface of the panel that depicts the demure headdress of the lady of the house, a big, black, ugly fly has dared to land. However, when we try to swat it away, we realize that the artist has fooled us with his artistry, for this is not a real fly perched on the surface of the painting, but rather a fictive one depicted

within the composition itself. As if to further demonstrate his mimetic skills, the artist has not only included another entomologically correct fly crawling beside the plate of fruit – although this time clearly 'inside' the painted scene – but he has also precariously balanced a sliver of bread on the front of the table-ledge, an object that, like the fly on the headdress, seems to be positioned somewhere between our space and the fictive space of the portrait.

It is the fly that appears to have just landed on the panel's surface, however, that suggests that something more than a mere visual gag is in progress. Indeed, one could argue that this insect and, especially, the deliberately illusionistic way in which it has been painted tell us something important about the professional ambitions of this particular artist and, more generally, about the aspirations of art (or rather, 'Art') itself in this period, for a fly that can fool a beholder is a visual trope with a long history. Already in the mid-15th century, the Italian artist Antonio Filarete had used just such an example to demonstrate the outstanding abilities of Giotto, perhaps the most famous artist of the later 13th and early 14th centuries. In his treatise, Filarete claims that, while still a mere apprentice, Giotto had painted flies which his master Cimabue had tried to flit away with a rag, thus demonstrating just how much skill the younger artist must have had if he could fool even a fellow professional painter.

Much more venerable was the story told by the ancient Roman writer Pliny the Elder in his 1st-century collection of anecdotes about famous artists, a text ultimately based on even older sources. According to Pliny, two of antiquity's greatest painters, Zeuxis and Parrhasios, had a competition to see who was better at replicating the real world in his art. First up was Zeuxis, who produced a painting of a bunch of grapes that was so convincing that birds flew up to it and tried to eat the fruit. Then Parrhasios decided to go one better and invited his rival to see the result. Zeuxis impatiently dashed to Parrhasios's workshop to see the new picture and, in his

haste, tried to pull off the curtain that the latter had apparently hung over the painting. At that very moment, however, Zeuxis realized that he had lost the competition, for the curtain covering the painting was in fact a fiction, merely an illusionistic representation along the lines of the curtains that seem to be being drawn open in Raphael's *Sistine Madonna* (see Figure 1). But this time, it was not just a flock of birds that had been fooled; rather, Parrhasios had fooled one of the greatest artists of the ancient world, thereby demonstrating his own superior skills as a painter.

In the 16th century, similar anecdotes were repeated again and again with slight variations. For instance, the Italian writer Pietro Aretino described a mother ewe bleating joyfully when she saw a lamb in a painting by Titian, while another writer claimed that a dog had barked at a portrait of its master painted by Dürer. In his *Lives of the Artists* published in two editions in the mid-16th century, Vasari implied that, as in Pliny's tale, not only animals but people too could be fooled by such *trompe l'oeil* paintings. In one such anecdote, Vasari described passersby paying homage to what they thought was the pope himself, but actually was just a portrait left by Titian to dry in a window. The art theorist Zuccaro similarly described not just random pedestrians, but an actual cardinal who mistakenly had tried to hand a pen to another pontiff's portrait, this time by Raphael, in order to obtain a signature on a document.

Whether any or all of these tales are actually true is irrelevant, since it was by the very act of repeating such *topoi*, or stock themes, most probably initially inspired by Pliny's well-known tale, that we begin to appreciate just how highly Renaissance culture valued an artist's ability to mimic the real world accurately and convincingly. Thus, choosing to depict a fly as if it had just landed on the surface of a painting in which he had very probably portrayed himself was a highly appropriate way for the Master of Frankfurt (whoever he may have been) to allude visually to both his artistic skill and his prestigious Classical predecessors.

Competing with the Classical and natural worlds

In general, Renaissance artists sought not only to imitate nature and evoke the Classical age, but actually to surpass them both. Indeed, competing with the prestige of antiquity and the reality of the natural world became a touchstone for some of the most self-consciously innovative art of the Renaissance. For instance, Dürer's superb 1504 engraving of *Adam and Eve* (Figure 14) used as models for its figures two of the most famous antique statues known in the Renaissance, the *Medici Venus* and the *Apollo Belvedere* (so named because the former belonged to the Medici family and the latter was displayed in the Belvedere courtyard in the Vatican). Here, in a very precisely imagined vision of Eden where even a cat and a mouse (both in the foreground) are still able to live in peaceful co-existence in a pre-Lapsarian world, the perfect bodies of Adam and Eve, as yet free from sin, are literally embodied by two icons of Classical art, but now set within an explicitly Judaeo-Christian context. In this image, which as a print could be distributed to discerning collectors far and wide, Dürer demonstrated to his contemporary beholders that, despite his German pedigree, he felt just as much at ease with deploying such Classical prototypes as any Italian artist, who would have had the benefit of literally being surrounded by the remains of the ancient Roman world.

The marble statue of the Apollo Belvedere, which was itself a Roman copy of an even older Greek original, also served as the model for a superbly crafted, partially gilded dark bronze statuette by the north Italian sculptor Piero Jacopo Alari Bonacolsi, known by the nickname 'Antico' precisely for his affinity to such antique prototypes (Figure 15). This small-scale work not only demonstrated the sculptor's ability to absorb and reinterpret Classical art in a particularly skilful manner, but also attested to his patron's exquisite taste and intimate familiarity with Classical learning. In this particular case, the patron in question was the

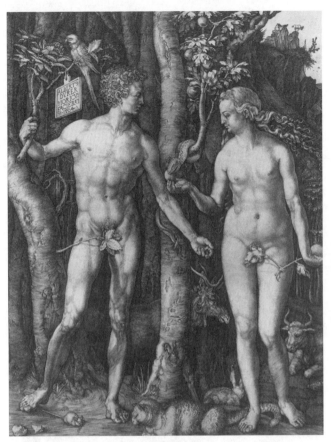

14. **Albrecht Dürer,** *Adam and Eve,* **engraving (second state), 1504**

Marchesa of Mantua, Isabella d'Este, one of the most famous
collectors of actual ancient objects in this period, as well as a patron
who very much favoured classicizing subjects in her commissions
for 'new' works of art as well. For both Isabella (who we will
consider again in Chapter 6) and Antico, ancient models, both
visual and literary, were not only aesthetically pleasing and
dramatically satisfying in and of themselves. Rather, these models

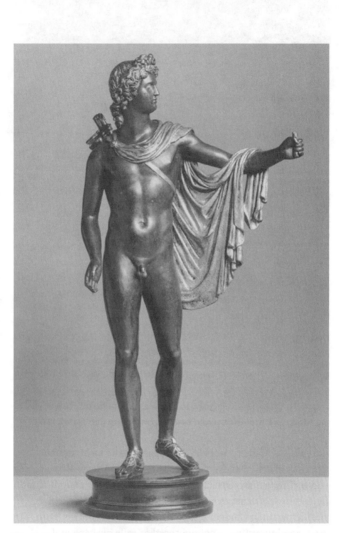

15. Antico (Piero Jacopo Alari Bonacolsi), *Statuette of the Apollo Belvedere*, partially gilded bronze with silver inset eyes, c. 1497–8

were also valued simply *because* they were ancient, such was the prestige of the long-lost 'golden age' of Rome and Greece worshipped by Renaissance humanists and their followers. Indeed, this sense of yearning for a lost past and a desire to reawaken it in body and spirit in the present day can even be seen in the motto adopted in the later 15th century by Lorenzo de' Medici, head of one of the most influential families in Renaissance Italy: *le temps revient* – literally, 'time [or, better, the past] returns'.

One of the qualities most admired in the Classical statues, coins, and gems that were the most common surviving ancient artefacts known in this period was their ability to represent in a realistic and convincing manner the human body. Artists in both the North and South sought to rival and then surpass the ancients in this respect, as well as by depicting illusionistically other natural phenomena not generally seen in the Classical art available to Renaissance beholders, such as flora, fauna, and even entire landscapes. In the case of Leonardo da Vinci, page after page of drawings attest to his desire to unravel the mysteries of the natural world through close studies of plants, animals, and the human body, as seen in his splendid sketch of a dissected human chest, shoulder, and arm in four slightly different positions (Figure 16).

Leonardo's proto-scientific approach to exploring phenomena from limbs to landslides in the later 15th and early 16th centuries may have been inspired, at least in part, by the highly precise renderings of nature seen in Northern European painting already in the first half of the 1400s. Northern artists such as Jan van Eyck, whom we will consider in the next chapter, concentrated primarily on depicting with minute accuracy all aspects of the real world, from fruit and flies to fabrics and furnishings, a kind of detail-oriented painting perfectly suited to the oil-paint medium that seems to have been developed first in the Netherlands in the early part of the 15th century. In Italy, artists like Leonardo, perhaps influenced by such Northern

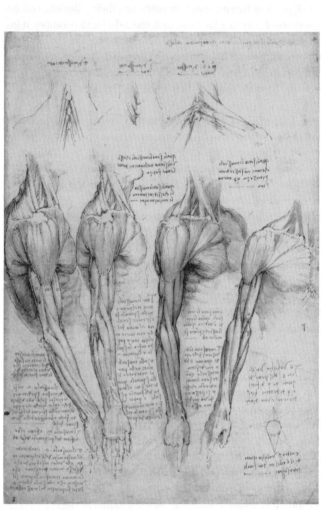

16. Leonardo da Vinci, *Four sequential studies of the superficial anatomy of the arm, shoulder, and chest*, pen and ink with wash on paper, c. 1510–11

examples, also sought to observe nature ever more carefully. However, in comparison to artists working in the North, Italian practitioners were somewhat more concerned with accurately depicting human anatomy in particular through drawings of living models and dissections of dead ones, as seen in Leonardo's almost cinematic rendering in pen and ink of the human arm viewed as if in slow motion.

Perfecting perspective

Equally important to Italian artists, however, was the accurate and convincing depiction of buildings and architectural spaces. While in the North, precisely rendered objects were what was crucially needed to suggest that an artist had captured the 'real' world in his or her art, in Italy, convincingly realistic objects and people had to be positioned in equally illusionistic spaces. Although, ever since Giotto, artists had been intuitively perfecting the depiction of three-dimensional structures and spaces by a process of trial and error, in the early 15th century, it suddenly became possible to do so with mathematical precision.

In his book *De Pictura (On Painting)* first published in Latin in 1435, Alberti, whom we have already encountered in previous chapters, sought to codify mathematically the principles of linear perspective, a technique that allowed both solid objects and architectural spaces to be depicted systematically and convincingly on a flat painted or sculpted surface through the use of orthogonal lines receding to a single vanishing point ideally coordinated to the eye level of the beholder. Alberti himself apparently did not use the technique he described in any paintings or sculptures of his own, instead relying extensively on the experiments of others when writing his book. First and foremost among these was the sculptor and architect Filippo Brunelleschi, who had ingeniously completed the great octagonal dome of Florence's Cathedral, a project finally finished in 1436, the same year Alberti published an

Italian-language edition of his treatise dedicated to (among others) Brunelleschi. Already in about 1424–5, Brunelleschi had used local Florentine architectural landmarks, including the Baptistry located in front of the Cathedral, to demonstrate his mathematically based technique of depicting buildings and urban spaces illusionistically. Soon, other artists working in paint, fresco, and even relief sculpture also began to use Brunelleschi's approach, especially once Alberti's treatise became available. However, given that the majority of the surviving copies of this text are in Latin, the language of elite humanist scholars and patrons, it seems likely that most practising artists learned to use linear perspective by word of mouth and by looking closely at early 15th-century works such as the highly illusionistic *Trinity* fresco painted by Masaccio or the perspectival marble and bronze reliefs produced by the sculptor Donatello.

The painter Domenico Veneziano was one such artist, although he may also have benefited from discussions with his colleague Piero della Francesca, a painter who wrote mathematical treatises of his own later in the century, including one on perspective. Domenico's *St Lucy Altarpiece* of c. 1445–7 (see Figure 3), discussed briefly in the second chapter, demonstrates not only a thorough understanding of the principles of linear perspective, but only a decade after Alberti's treatise first appeared, shows that he was also trying to manipulate the technique for his own ends. Although the altarpiece's main central panel is clearly intended to show a single, unified scene, Domenico's decision to set his figures within a tripartite architectural structure consisting of an arcade with slightly pointed arches harks back visually to earlier triptychs. Nevertheless, at first glance, the space seems to be constructed according to the rules of linear perspective. Indeed, if one approached the altarpiece from the position of a kneeling devotee or priest at the altar, the first thing one would have probably noticed from this position was the intricate and highly detailed floor tiles along the bottom edge of the painting, just above the predella. Almost like a diagram in a mathematical treatise, these tiles are foreshortened and recede convincingly from the panel's lower edge

to the base of the Madonna's throne. The arched arcade and shell niches in the background appear to be equally carefully constructed along strictly mathematical principles.

But appearances can be deceiving: although the floor tiles are indeed correctly depicted according to the rules of linear perspective, the rest of the architecture and the figures set within it are profoundly ambiguous. For instance, while the face of the arcade along the top edge of the painting seems to be at the very front of the imaginary picture plane's surface, in the middle and lower areas of the painting, it becomes evident that this cannot be the case since the four side saints are clearly supposed to be standing in front of this structure, not underneath its arches. Likewise, while the Madonna seems at first glance to be enthroned within the central shell-topped niche, the position of the columns makes it apparent that she must actually be seated quite some distance in front of the niche, with the lower edges of her robe suggesting that she may even be positioned slightly in front of the first row of columns. One soon realizes that the Madonna must also be enormous in comparison both to the architecture and the other figures. Indeed, were she to stand up, not only would she dwarf the saints beside her, but she would probably be almost as tall as the columns that flank her throne.

The very precisely rendered floor tiles confirm that Domenico was well versed in the practice of linear perspective. His apparent 'errors', therefore, should be seen instead as consciously willed subversions of the mathematical principles involved, subversions intended to allow the painting to best achieve its main purpose, namely, to be a successful devotional image and a work that would glorify both the church in which it was originally installed, S. Lucia dei Magnoli in Florence, and the wealthy patron who had paid for it. So, although Domenico's patron clearly wanted an altarpiece that looked 'up-to-date' thanks to perspectival elements such as the floor tiles and the use of a single unified scene for the main panel, a very traditional and hierarchical devotional structure nevertheless

remained embedded in the painting's composition. This was achieved by using architectural elements to fence off visually the central Madonna and Child from the side saints (who included the church's namesake, St Lucy, and two of Florence's patron saints, John the Baptist and Bishop Zenobius) as had been the case in earlier triptychs, and by having the Virgin tower physically and symbolically over all the other figures. Likewise, the panel's somewhat hallucinatory spatial and inter-figurative relationships would have emphasized the visionary aspects of the scene for the devout beholders who originally gazed upon the painting.

From the early 15th century onwards, the technique of linear perspective described by Alberti was used by artists in highly imaginative ways in order to create visually convincing spaces for sacred and secular subjects, thereby turning paintings and reliefs into windows onto imaginary worlds that could seem to rival reality itself. Perhaps the culmination of this approach is another work by Leonardo, his much-reproduced and much-damaged fresco of the Last Supper (Figure 17). This work had already started to flake and peel off the wall of the refectory of the Church of S. Maria delle Grazie in Milan shortly after Leonardo had finished painting it in the later 1490s using an experimental oil-on-plaster technique that was almost immediately deemed a failure from a technical point of view. The enduring success of the work in the public imagination, however, is due to a combination of the artist's great sensitivity in depicting naturalistically the varied emotional states of the participants at this Eucharistic drama and his equally convincing spatial setting.

The painting's patron was Ludovico Sforza, Duke of Milan, whose attachment to the monastery of S. Maria delle Grazie was such that he dined with the monks twice a week in the refectory, that is, in the very room where Leonardo's rendition of history's most famous

17. **Leonardo da Vinci, *The Last Supper*, mural painting, 1495–7/8**

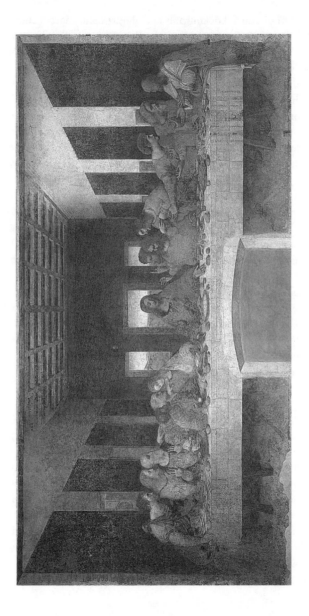

meal was located. Looking only at a photographic reproduction of the composition, one might assume that the fictive dining room is a seamless continuation of the real refectory's space. However, once again, as in the case of the *St Lucy Altarpiece*, the artist has actually manipulated the rules of linear perspective for his own purposes. Perhaps most significantly, the single vanishing point that this technique requires is set, like the painting itself, well above the eye level of the beholder standing or seated in the refectory, thus making it impossible to ever see the work from its ideal viewing position. Similarly, the table that dominates the foreground of the composition, while appearing to be properly foreshortened on its own, is actually positioned extremely ambiguously in relation to the figures and the fictive architectural space, for which it appears to be much too long and narrow upon closer inspection. And, once again like the *St Lucy Altarpiece*, the central sacred character of Christ himself is actually painted on a much larger scale than any of the surrounding apostles. Leonardo's *Last Supper*, therefore, subverts the strict rules of linear perspective and relative proportionality in order to achieve a particular effect, namely, a sense of narrative urgency and dramatic tension swirling all around the figure of Jesus seated calmly and serenely at the very centre of the sacred scene – a scene that seems to be both part of, yet mysteriously separate from, our own physical world.

Conclusion

Linear perspective, like the close observation of nature, the human body, and Classical models, was seen by Renaissance beholders as something worthy of careful study and theoretical contemplation in its own right. However, when it came to deploying such approaches in actual works of art, painters, sculptors, and their patrons were perfectly willing to modify and adapt 'reality' – whether past or present, spatial or natural – for their own purposes, artistic and otherwise. As we shall see in the following chapter, such tensions between the real and the ideal also haunted one of the Renaissance's most popular genres, the portrait.

Chapter 5
Portraiture and the
rise of 'Renaissance man'

Images of individuals

According to the influential mid-19th-century Swiss historian Jacob
Burckhardt, whom we encountered briefly in the first chapter,
the Renaissance was the moment when the modern notion of
'individuality', indeed, the very concept of the self as an autonomous
entity, first fully manifested itself, eventually giving rise to an ideal,
multi-talented 'Renaissance man' or *uomo universale*. Since
the publication of Burckhardt's *The Civilization of the Renaissance
in Italy* in 1860, scholars have vigorously debated the merits
of such broad and sweeping claims and have pointed out that
well-rounded, self-aware individuals can be found in earlier
periods as well.

Although it is notoriously difficult to prove or disprove theories
about a paradigm shift in the *Weltanshauung*, or 'world view', of a
particular age, there is no doubt that the Renaissance did see an
explosion in the production of painted and sculpted portraits of
recognizable individuals. Of course, independent painted portraits
of a very small number of kings and pontiffs had existed long before
the Renaissance, with even some slightly lower-ranked members
of the elite, such as bishops or high nobles, portrayed in effigy on
their tombs. Likewise, donor portraits, in which the wealthy and
powerful patron of a work such as an altarpiece would be depicted

within or at the edge of a sacred scene, had also existed since the Middle Ages.

Similar portrayals of the sacred and secular elite certainly continued to be produced throughout the 15th and 16th centuries. But beginning in the early 1400s, other categories of sitters, such as women, well-to-do merchants, and even artists, also began to be represented in ever-greater numbers in independent portraits. And even in portraits of the traditional elite, a growing interest in individual psychology and physiology is evident, thereby reflecting the period's new approaches to depicting space, nature, and human anatomy increasingly naturalistically. The very interest in individual portraiture also reflected the Renaissance revival of Classical antiquity, since ancient writers had focused on the biographies of famous individuals, while ancient coins and marble busts of Roman emperors and their less exalted citizen-subjects still existed to be studied, admired, and used as models for new commissions by Renaissance patrons, collectors, and artists.

We have already encountered several portraits in this book, suggesting just how varied this genre could be. As in centuries past, a king is portrayed as a participant-donor in the *Lamentation* commissioned by Alfonso II for a Neapolitan church, but now the patron is included as a fully three-dimensional and emotionally engaged being, demonstrating the sculptor's sophisticated understanding of the human body (see Figure 11). Similarly, an elite noble is shown on a page of an illuminated manuscript produced in the later 15th century, but now the aristocrat is a woman, Duchess Mary of Burgundy, and the objects, fabrics, and spaces that surround her exhibit an appreciation of the new taste for naturalistic depiction (see Figure 9). However, it is in the double portrait of an artist and his wife that we discussed at length in the previous chapter that we see just how far portraiture had expanded its reach by the later 15th century (see Figure 13). In this image, we see a well-to-do, but certainly not aristocratic, artist-craftsman and his wife portrayed with as much care as would have been demanded

by a pope or prince in centuries past. Although poorer men and women were still resolutely excluded from the growing fascination with the individual that Burckhardt identified as a key characteristic of the Renaissance, there is no doubt that a focus on the self and on projecting one's own image to the wider world had begun to express itself across a much broader spectrum of society than had previously been the case.

When we look at a Renaissance portrait, we often assume that the image is a straightforward depiction of what the person portrayed 'really' looked like, as though we were gazing upon a kind of painted or sculpted version of a photograph. However, as we well know, even photographs can be highly manipulated images rather than transparent representations that faithfully mirror reality. Just as a 21st-century photographic portrait can involve the use of flattering lighting, specially selected clothing, and a bit of make-up – not to mention the services of a programme such as PhotoShop to airbrush any unattractive wrinkles or blemishes from the digital image file before we hit the 'print' button – so too was a Renaissance portrait a very deliberately crafted and carefully constructed thing. In the portrait of the artist and his wife, for instance, we see the couple dressed in their best clothes, with the things that surround them, from the stock-gillyflowers and cherries to the suggestive flies, all assiduously considered for their visual and symbolic significance.

In fact, it is helpful to assess Renaissance images of individuals in terms of their qualities as portraits versus their success as likenesses, with the two categories not necessarily always overlapping. So, for instance, we know that Leonardo used preparatory drawings he had made of living models' faces and bodies as the basis for his very convincing likenesses in the *Last Supper* (see Figure 17), but we could not really, strictly speaking, call these images 'portraits'. Similarly, we know from documents that, in her old age, Queen Elizabeth I of England allowed only a limited number of pre-approved templates to be used by artists when

painting her image. These authorized models depicted the Queen as being still young and beautiful, with the resulting works clearly intended to be understood as portraits, but certainly not to be considered accurate likenesses of the ageing monarch (see Figure 24). Similarly, Titian painted a portrait of Isabella d'Este, a patron and collector we discussed briefly in the previous chapter, at the age of 60 as though she were still little more than a teenager.

Even in portraits that seem to be less obviously flattering fictions, one needs to be wary of trying to separate reality from idealization. Indeed, only in a very small number of cases where several portraits exist of the same sitter painted by different artists can we even begin to try to sift the one from the other. But 'flattery' was not just about making ladies of a certain age look young and perky; rather, it was also about putting the best possible 'spin' on the social, economic, and political status and aspirations of the individuals portrayed.

Portraiture in Italy

For instance, Titian's later 1530s portrait of Francesco Maria della Rovere, Duke of Urbino, shows him as a mature man, with a slightly receding hairline and some furrows lining his brow (Figure 18). But the Duke's steady, steely gaze peering out from a light-coloured face that stands out against a generally dark background is clearly meant to attest to his courage and determination, with his wrinkles simply confirming that he must be wise and experienced as well. Such attributes would, of course, have been exactly what a man who was a famous *condottiere*, or professional army general, as well as a titled noble, would have wanted to project when commissioning this portrait. In fact, the writer Pietro Aretino assumed that the portrait as a whole and the various objects depicted within it were a kind of visual summary of the Duke's entire career as seen, for instance, in the deluxe imported German suit of armour he wears and the feather-topped helmet displayed on the red velvet-covered shelf behind him, or in the various batons seen on this same ledge

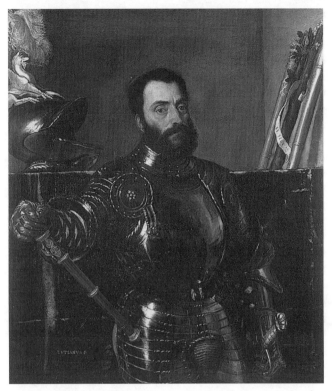

18. Titian (Tiziano Vecellio), *Francesco Maria della Rovere, Duke of Urbino*, oil on canvas, c. 1536–8

and in his right hand, each representing one of the separate commands he had held with the armies of Venice, Florence, and the papacy.

Interestingly enough, the Duke's wife, Eleonora Gonzaga, daughter of Isabella d'Este, was also painted by Titian in a pendant portrait presumably intended to be hung beside her husband's image. But in contrast to the ideal manly attributes of a Renaissance warrior-prince standing haughtily to attention, she is shown in a

much more relaxed, seated pose dressed in fine velvet brocade and frilly lace wearing a tasteful selection of jewellery, her hair tucked into a luxurious embroidered cap, all most appropriate for a rich, discerning, yet demure nobleman's wife. To make the point absolutely clear, while the objects that surround the Duke seek to portray him as the ideal military man, the Duchess's most prominent attribute is a little dog, traditional symbol of marital fidelity.

Almost exactly a century earlier, Alberti had written that art should strive to show the 'movements of the soul' through the 'movements of the body'; in other words, to depict the inner person through outward signs. But it is impossible ever to discern with any confidence from paintings like those of the Duke and Duchess of Urbino what they 'really' looked like, let alone what they were 'really' like as individual personalities. Instead, from their carefully considered poses and attributes, we can only determine how they hoped and wished to be seen by their contemporaries and, crucially, by their descendants, since portraiture almost always served a commemorative and dynastic function as well.

Although famous Italian artists such as Titian and Leonardo da Vinci produced portraits throughout their careers – including, in the latter case, the iconic *Mona Lisa* – the genre of portraiture itself was often seen by Italian Renaissance art theorists as lower on the artistic scale than, say, major religious paintings or historical narratives. Michelangelo, for instance, only ever drew one proper portrait, so much did he distain a genre that he believed required only the ability to copy reality mechanically rather than demanding true artistic innovation or ingenuity. Indeed, Michelangelo famously told a contemporary who had complained of his sculpted effigy of a Medici duke looking nothing like the sitter that, in a 1,000 years, no one would know or care about the man's appearance, whereas all would still marvel at the artist who had so skilfully carved his statue.

Portrait-painting in the North

In Northern Europe, in contrast, portraiture was more generally appreciated as an art form, especially after the Reformation, when commissions for religious images and objects had all but disappeared in Protestant regions, to be replaced by an ever-greater number of commissions for secular works such as portraits. In fact, given the genre's higher status in the North, it is no surprise that some of the most famous and intriguing portraits of the Renaissance were painted by artists working in England, France, Germany, and the Low Countries.

One of the best-known Renaissance portraits is by the Netherlandish painter Jan van Eyck who, with his brother Hubert, had produced one of 15th-century Europe's most remarkable altarpieces, a multi-panelled winged retable known as the *Ghent Altarpiece*. In 1434, two years after completing this work, Jan painted a much more humbly scaled, but equally memorable double portrait depicting a couple standing hand-in-hand in a domestic interior (Figure 19). This panel is known as the *Arnolfini Portrait* since documentary evidence suggests that the man depicted may be Giovanni Arnolfini, a wealthy merchant from the Italian city of Lucca who made his fortune as an expatriate in Bruges, a town in present-day Belgium, and who was married to Giovanna Cenami. The panel is not only an important early example of a work in the new medium of oil paint first developed in the North and then later taken up by Italian artists, but also possibly the first significant portrait made of sitters who were not part of the traditional sacred or secular elite. Although the couple were clearly well-to-do, as suggested by the expensive fabrics, furnishings, and fittings displayed throughout the composition, they were certainly not aristocrats, but rather a self-made man and his wife. The couple are shown in full-length, a pose previously reserved almost exclusively for the very elite of the elite. Moreover, they are shown within their own home, surrounded

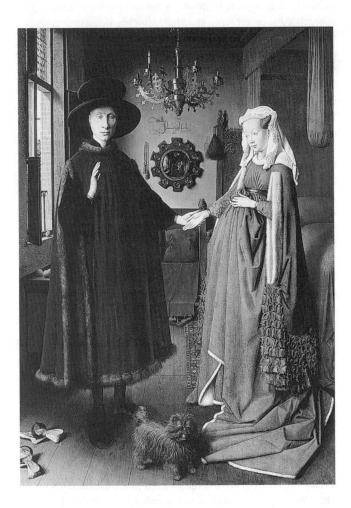

19. Jan van Eyck, *The Arnolfini Portrait*, oil on panel, 1434

by their own possessions, rather than as donors within a larger religious scene.

Like Titian's portrait of the Duke of Urbino a century later, however, the couple in Jan's portrait also use their surroundings to attest to their circumstances and aspirations. But, apart from documenting their wealth, what exactly is going on in this image? The couple seem to have entered the room only very recently, since we see in the foreground that the man has just kicked off his shoes. The dog at the lady's feet presumably alludes once again to her wifely fidelity, while the ceremonial laying of one hand on the other, combined with the man's solemnly raised right hand, gives us the sense that we are witnessing some kind of pledge or oath. Not surprisingly, scholars have in fact suggested that the painting may, like the portrait of the artist and his wife we saw earlier, have been painted to commemorate the vows exchanged by the couple at their betrothal or engagement.

But who exactly has witnessed this legally binding ritual? In the convex mirror in the background, we see two small figures, presumably the people to whom the man is gesturing and who, implicitly, must be standing in front of the scene portrayed. In fact, the figures may well be intended to represent the artist, Jan van Eyck, and one of us, as the implied beholder standing beside him. This suggestion is given further support by the fact that directly above the mirror we see written on the wall the date 1434 and the words 'Jan van Eyck has been here', a phrasing that is as much a kind of confirmation of his presence as a witness as it is a signature. So, this portrait may well commemorate officially the couple's marital union, as well as attest visually to their economic and social success and material prosperity.

By possibly including a miniature self-portrait within the mirror, Jan may have also wanted to make a statement about his own abilities as an artist: not only was he able to depict convincingly an exceedingly complex object such as a convex mirror, but he could

portray the entire natural world on the surface of a painting as if seen in a mirror. Significantly, Jan also painted what may be one of the earliest independent artist's self-portraits in the year between completing the *Ghent Altarpiece* and beginning the *Arnolfini Portrait*. As we have seen, by the end of the 15th century, other artists like the Master of Frankfurt were unambiguously depicting themselves in ways that signalled their professional aspirations. But just how far the status of elite artists had risen by the turn of the 16th century is best demonstrated by one of the most remarkable self-portraits of all time, Dürer's audacious self-portrait of 1500 (Figure 20).

In this image, the artist showcases his incredible technical skill through precisely rendered details such as his shiny, curling hair and the individual tufts discernible on his luxurious fur-trimmed collar. Perhaps even more significantly, Dürer portrays himself in a full-frontal pose, which recalls earlier iconic portraits of God the Father as *Salvator Mundi*, or Saviour of the World. Combined with the prominently displayed, semi-millennial date of 1500 painted above the artist's initials to the left of his head, this suggests that Dürer may be trying to forge a deliberate visual link between artistic and divine creativity. The artist, in other words, has now become a god and, like God himself, he too can conjure up the world and all its inhabitants in his art – a theme we will consider at greater length in the ninth chapter. In the context of portraiture as a genre, however, this daring display of artistic self-confidence, perhaps even hubris, highlights the important connections that exist between this art form and new Renaissance attitudes towards individuality, originality, and creativity.

The possibilities of portraiture: Holbein's *Ambassadors*

These links are further demonstrated in one of the most spectacular portraits produced in this period, a work that on the one hand seems to confirm Burckhardt's ideal of the multi-talented

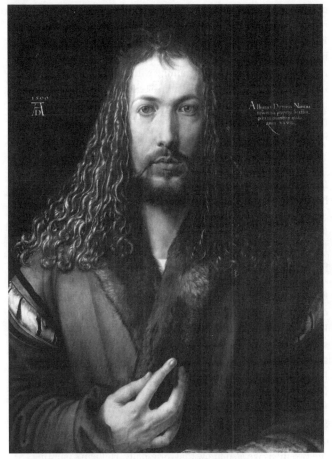

20. Albrecht Dürer, *Self-Portrait*, oil on panel, 1500

'Renaissance man' but, on the other, by its very exceptionality, reminds us that such ideals were inevitably realized by only a very limited number of wealthy, elite, and usually male humanist-scholars, nobles, and clerics. The work in question is known as *The Ambassadors* (Figure 21) and was painted by the German artist Hans Holbein the Younger in 1533, after he had

moved permanently to England, possibly in response to the religious iconoclasm he had witnessed in the Swiss city of Basel, his professional base for many years. Ironically, of course, by the later 1530s, England too would begin to dismantle its religious artistic heritage, beginning with Henry VIII's decision in 1536 to dissolve all Catholic monasteries and appropriate for himself, as head of the newly formed Church of England, their property, including any art that wasn't first destroyed by iconoclastic mobs.

But this was all yet to come when the 29-year-old patron of Holbein's great double portrait, Jean de Dinteville, wrote to his brother in May of 1533: 'Monsieur de Lavaur did me the honour of coming to see me, which was no small pleasure to me.' Dinteville was the learned and noble-born French Catholic ambassador to the English court at the time that the Henry VIII was in the process of divorcing his wife Catherine of Aragon and marrying in her stead Anne Boleyn, a Protestant sympathizer the king hoped would finally give birth to a male heir. In the portrait, Dinteville stands on the left, with Georges de Selve on the right. Selve was not only Dinteville's close friend, but also the Bishop of Lavaur in the southwest region of France and a fellow French Catholic diplomat assigned to various European courts, including the papal court in Rome. Dinteville's letter refers to a secret visit by his friend at a time when the former was intensely homesick for France and, especially, for his family seat at the Château de Polisy not far from Paris. Significantly, the name of the château is inscribed at the centre of the terrestrial globe displayed on the lower shelf between the two men. We also know that, originally, Holbein's painting was hung in Polisy, presumably in one of the building's grand public rooms.

In addition to the globe, many other meticulously depicted objects are displayed on the two-tiered shelving unit. On the top level, there is a celestial globe of the heavens, together with a number of other scientific instruments related to astronomical measurements and

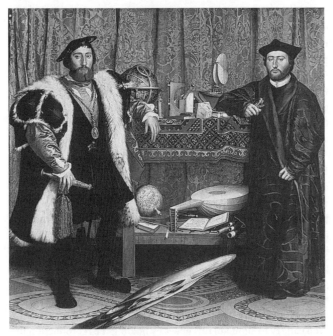

21. **Hans Holbein the Younger,** *The Ambassadors*, oil on panel, 1533

time-telling, such as two quadrants and a sundial. On the lower
shelf, besides the terrestrial globe, we also see an arithmetic
book, a set of flutes in a case, a lute with one broken string, and a
hymn-book. While this very diverse collection of items confirms
that these are exactly the kinds of 'universal' men so admired by
Burckhardt, the objects on the lower shelf in particular suggest that
the image may well be more than just a visual enumeration of the
sitters' impressively varied interests. In fact, a number of items
appear to evoke the theme of division and discord: the arithmetic
book is open to a page headed with the Latin word for 'divide'
(*dividirt*), the hymn-book is a well-known German Protestant
publication left open to a hymn associated with the controversial
figure of Luther himself, while the lute's single broken string and

the fact that one flute from the set stored in the case is missing all emphasize disruption and disharmony. Interestingly enough, both men were actively involved in trying to soothe the religious and political differences that were engulfing Europe at the time, Dinteville through his work as the ambassador of the French Catholic monarch François I to Henry VIII's court, and Selve by giving important speeches at conferences organized on the Continent to try to heal the ever-growing rifts between Protestants and Catholics.

However, the most striking – and certainly the most visually discordant – element in the entire painting is the strange grey shape that seems to float almost in front of the composition between the two men. This is actually a very complex anamorphosis, an intentionally distorted image that only becomes visually intelligible in this painting if the beholder stands on the right side of the painting and looks across its surface from a raking angle. From this position, the shape suddenly and almost magically turns into a hollow-eyed human skull, a symbolic reminder of death, mortality, and the brevity of human life. It is, in short, a *memento mori*. (You can try to simulate this effect by holding the reproduction in the present volume at a right angle to your eye and then looking closely at the shape from this angle.) Other artists, especially those working in Northern Europe in the 15th and early 16th centuries, had also included skulls in some of their portraits, either positioned under a sitter's hand or painted on the back of a picture. Likewise, playful anamorphosic images had become quite fashionable in courtly circles in the early 16th century. But the combination of these trends in the disturbing, distorted, free-floating skull seen in *The Ambassadors* was unique, a one-off.

Conclusion

The skull in *The Ambassadors* served as a visual testament to both Holbein's skill as an artist and his sitters' rather morbid fascination with death at a time of general religious and political unease.

Although from his letters, we know that Dinteville was quite depressed at having to stay away from his beloved Polisy for so long when he commissioned the painting, we should not see the image merely as the product of a gloomy ex-pat's highly personal preoccupations. Rather, the positive scientific possibilities alluded to by the measuring instruments found especially on the top shelf, together with the tiny sculpted crucifix that is just visible at the top left corner of the composition, as if peeping out from behind the green silk curtained backdrop, are elements of hope – in the former case, hope that mankind's ability to be logical and rational might yet resolve the problems of this world, and in the other, that faith in the one true God might one day lead to salvation in the next. However, these exceptional 'Renaissance men', like the exceptional artist who painted this portrait commemorating their friendship, as well as their hopes and fears, could not know that the trials and tribulations of this world would only become much worse in the years to come.

Chapter 6
Did women have a Renaissance?

Were there 'Renaissance women'?

In the previous chapter, we considered a small number of exceptional 'Renaissance men' portrayed in exceptional and, quite probably, highly idealized portraits. According to the historian Jacob Burckhardt, in this period, 'women stood on a footing of perfect equality with [such] men [and] The education given to women in the upper classes was essentially the same as that given to men'. The implication is that there must have been 'Renaissance women' to rival the likes of men such as Jean de Dinteville and Georges de Selve. But did women actually have a Renaissance? In an influential essay on this question published by Joan Kelly-Gadol in 1977, the answer is a resounding 'no'. Despite Burckhardt's claims to the contrary, even the most intelligent and noble-born woman could not be considered the social or political equal of men, and only a tiny minority of elite women received any kind of formal education. Economically, with very few exceptions, women were almost entirely dependent on men, unless they happened to become the widows of wealthy men without subsequently remarrying, for upon marriage, a woman transferred her social status and wealth (in the form of a dowry) from her father's home to that of her husband. In fact, Kelly-Gadol has argued that, compared to Medieval women, Renaissance women actually had fewer legal rights, less economic power, and less political

influence than their predecessors. In her view, the Renaissance was most certainly not a time of innovation and opportunity for women.

Although such provocative conclusions have forced scholars in a number of disciplines to reconsider many of the basic assumptions about Renaissance culture that had been widely accepted since Burckhardt's day, the situation in the realm of the visual arts is not nearly as straightforward as Kelly-Gadol implies. It is undoubtedly true that women in the labouring classes were probably not better off in material, political, or social terms during the Renaissance – but then, neither were most men. At the middle socio-economic level of artisans, craftsmen, and merchants, it is somewhat less clear whether the majority of women were better or worse off than in previous centuries. However, at elite levels, a small number of women patrons did manage to make their presence felt through their artistic commissions as much, if not more than, any of their Medieval predecessors. Likewise, it was in the 16th century that we begin to see for the first time in history a very small number of women forging successful careers as professional artists. At the same time, much more common than either women patrons or women artists were the literally thousands of images of real and ideal women – whether Virgins or Venuses – that were produced during the Renaissance, primarily for the visual consumption and delight of male beholders. In this chapter, we will explore the rubric of 'women and the visual arts' in light of all three issues, namely, women as subjects of art, women as patrons, and women as artists.

Images of women

The ways in which attending to questions of gender can help us gain a better appreciation of Renaissance art is suggested by considering one of the many portraits of women produced in this period: the 16th-century Venetian-born painter Lorenzo Lotto's painting of a richly dressed young woman with an engaging outward gaze

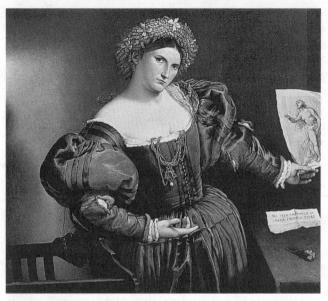

22. Lorenzo Lotto, *Lucrezia Valier*, oil on canvas (transferred from panel), c. early 1530s

(Figure 22). The tilt of the sitter's head and her pointing finger direct the beholder's eye to a sheet of paper in her left hand on which is sketched a nude woman about to plunge a dagger into her breast. An educated 16th-century beholder would immediately have recognized this as an image of Lucretia, the young Roman wife who committed suicide in order to uphold her honour after being raped. This interpretation is confirmed by the inscription on another piece of paper on the table beneath the drawing, which states in Latin: 'No shame lives in the example of Lucretia.' Based on the allusions to the ancient tale of Lucretia and other documentary evidence, scholars have suggested that the painting is a portrait of Lucrezia Valier, a woman from a wealthy family who married in 1533.

Most past scholarly discussions of this image have focused on

attributing the canvas, examining its iconography, and attempting
to identify the sitter. But by considering the fact that the person
portrayed is a woman, very different kinds of questions come to
the forefront. For example, it has generally been assumed that
the drawing held by the woman must have been made by a man
for an implied male beholder. However, by allowing for the
possibility that the author of the drawing may be the sitter
herself or that its 'message' may be intended for female beholders,
new interpretations begin to emerge. For instance, the fact
that the Lucretia in the drawing is shown in an heroic mode,
rather than as a figure for erotic contemplation, as is the case in
most other images of the subject in this period, suggests that
the sitter may have wanted to assert the young Roman matron's
suitability as a role model for women, rather than use the
story as an excuse for the sexual titillation of male beholders.
Turning to the sitter's costume, most scholars have considered
it only as an aid for dating and attributing the painting.
However, by assessing her clothing in light of the lives of
actual Renaissance women, one realizes that the choice
of dress could suggest that the painting was made to
commemorate one of the key events (marriage,
motherhood, widowhood) that shaped women's lives
in this period.

New research over the past few decades along similar lines
has also forced us to look anew at one of the most famous
female images of the Renaissance, Titian's so-called *Venus
of Urbino* (Figure 23). This painting of a reclining female
nude was completed in about 1538 for another Duke of
Urbino, Guidobaldo della Rovere, son of the duke whose
portrait we considered in the previous chapter (see
Figure 18). Today, inundated as we are by images of
scantily clad women in everything from beer advertisements
to *Baywatch*, the shock value of such a painting is
difficult to appreciate. But Mark Twain, writing in the
1880s, was very clear about the dangerous and highly sexual

allure of this work, which he saw hanging in Florence's Uffizi Gallery:

> . . . there, against the wall, without obstructing rag or leaf, you may look your fill upon the foulest, the vilest, the obscenist picture the world possesses – Titian's Venus the Venus lies for anybody to gloat over that wants to – and there she has a right to lie, for she is a work of art, and art has its privileges.

There is no doubt that Guidobaldo and the male visitors to his court, looking at this painting as it was originally displayed in his palace in Urbino, would have recognized its potent erotic qualities as much as Twain did.

But is this really an image of Venus? As Twain implied, giving the composition a mythological title (which, incidentally, is not found in any of the documents related to the original commission) that linked the image to prestigious ancient prototypes, both visual and literary, and displaying it as a work of Art (with a capital 'A') by a famous painter like Titian, would have provided its Renaissance and later beholders with a kind of intellectual 'cover-story' that could allow soft-core porn to be admired under the much more acceptable guise of Classical learning and tasteful art appreciation. In recent decades, scholars interested in how notions about gender both shape and are shaped by the wider culture have not only exposed the underlying male–female power relations implicit in having male beholders gaze upon such an image, but have also questioned whether the figure actually represents Venus in the first place. Indeed, apart from her nudity, there is nothing that definitively confirms that this is, in fact, a picture of a Classical mythological goddess. Instead, the rather grand interior setting recalls an elite Renaissance palace, perhaps like the one in Urbino, complete with luxurious bed linens and, in the background, two female maidservants and a *cassone*, or storage chest for textiles

23. **Titian (Tiziano Vecellio),** *Venus of Urbino*, **oil on canvas, before 1538**

and clothing that was usually given to a woman at the time of her marriage (see Figure 28). This has led some scholars to suggest that the female figure could actually be the mistress of the duke, or perhaps even his wife, rather than Venus. In any case, it is only by exploring Renaissance attitudes towards women, both real and ideal, and by examining the visual conventions used to portray lovers, wives, and goddesses, that one can begin to appreciate the complexities of such an image from the point of view of its original beholders, rather than see it merely as a work of 'Art' displayed on a gallery wall.

Women as patrons of the visual arts

Women's roles as patrons have also attracted increasing scholarly attention in recent years. As discussed in previous chapters, the role of the patron was crucial to art-making in the Renaissance. Indeed, one could argue that it was the patron who was the initiator of almost all significant artistic projects, and that it was the patron who determined an individual artwork's most important features and characteristics, including what material it was made from, where it was displayed, the subject it depicted, its size, and even, to a certain extent, its style and composition. Although knowing about a work's patron can never explain everything about an art object, understanding a patron's circumstances can provide us with important insights into why a particular work was commissioned and why it has some qualities rather than others. This is of particular relevance in the case of elite women patrons. Although many of their habits and concerns as patrons parallel those of their male contemporaries, there were important differences as well.

First, though, who exactly were the women who commissioned works of art in the Renaissance? By far the largest number whose patronage can be documented in this period were widows, like Atalanta Baglioni who hired Raphael to produce an altarpiece commemorating her murdered son (see Figure 7), or nuns living in convents. The prevalence of widows and nuns as art patrons is quite

simple to explain: only these women had the financial and social independence to pay for works of art themselves. As a young girl or a married lady, a woman was legally and financially under the control of first her father and then her husband. Indeed, it was only if a woman outlived her husband that she could finally decide whether and how to spend her money on commissioning works of art. Likewise, until joining a convent, a young nun would have been unable to exercise any kind of independent artistic patronage within her family home. Only upon joining a female religious community could collective decisions about commissioning art be made, although in many cases it was the abbess who was in overall charge of such projects.

Sticking to the secular sphere, the most common artistic commissions for women involved the tombs of their deceased husbands. Renaissance widows were exhorted to follow the Classical model of Artemisia, a widowed queen whose fabulous tomb for her husband, King Mausolus, became one of the seven wonders of the ancient world and has given us the word 'mausoleum'. Like Artemisia, 15th- and 16th-century widows were also usually concerned first, foremost, and often solely, with commissioning an appropriate funerary monument for their husbands. Some, but not all, monuments included an effigy of the deceased spouse. Sculpted effigies of women were rare, although wives did sometimes appear as kneeling donors together with their husbands in painted altarpieces or frescos painted for funerary chapels as seen, for instance, in the portrait of Nera Corsi in the Sassetti Chapel – although in this case, the project was commissioned by her still-living husband (see Figure 10). However, even if a widow did not make a personal appearance in her husband's funerary chapel, she could remind posterity of her role as its patron through an inscription or by including her own coat of arms as well as that of her spouse.

At the most elite levels, a very small number of women made much more impressive and longer-lasting marks thanks to their

non-funereal artistic patronage. We have already encountered Isabella d'Este, the Ferrarese-born patron and collector who was the Marchesa of Mantua, married to Francesco Gonzaga and mother of Eleonora, wife of the Duke of Urbino whose portrait we considered in the previous chapter. In the late 15th and early 16th centuries, Mantua was a small but influential north Italian town ruled by the well-respected, if not fabulously rich, Gonzaga family. Unusually, Isabella's artistic patronage took place while she was a wife, not a widow. Her very active patronage of artists, as well as her insatiable collecting habits, are extremely well documented by the more than 20,000 letters she wrote in the five decades before her death in 1539. From these letters, we know that, like her elite male contemporaries, she tried to buy the best antiquities she could afford and tried to hire the most famous artists of the day to work for her. By the end of her life, she had amassed an impressive collection of ancient artefacts and more 'modern' works such as the gilded bronze statuette of the Apollo Belvedere that we encountered in the fourth chapter (see Figure 15), all on what other aristocrats would have considered a shoestring budget.

Her desire to hire 'big name' artists and to collect both Classical and classicizing objects was very similar to the tastes of her elite male contemporaries, including her own brother Alfonso d'Este, who ruled her home town of Ferrara. However, the fact that she was not just an elite patron, but an elite *woman* patron does seem to have had an impact on her artistic commissions. For instance, while her male contemporaries commissioned portraits that emphasized their wisdom as well as their military and political power, as seen in Titian's portrait of the Duke of Urbino in armour, Isabella's portrait by the same artist at the age of 60 makes her look like a pretty young girl, which suggests that beauty, more than wisdom or courage, was the most valued trait for a woman in this period.

Gender may also have played a role in the way Isabella interacted with the artists she hired. In fact, some scholars have criticized Isabella for being a meddling and overly controlling patron when

working with the artists she hired to decorate her *studiolo* and *grotta* in Mantua's Ducal Palace, the small rooms in which she stored and displayed her collection of art and antiquities. From her letters, we can see that she did indeed try very hard to make sure that her artists stuck to her very detailed instructions. In the case of Perugino, Raphael's presumed teacher, she specified not only that the subject of his painting should be an allegorical combat between Erotic Love and Chaste Love, but also gave extremely precise instructions and sent the artist a detailed drawing of what the entire composition should look like, even going as far as sending a piece of string to indicate exactly how tall the largest figure in the painting should be. However, Isabella's preoccupation with controlling Perugino's artistic output was not just the result of unfounded paranoia. In the case of a painting by Andrea Mantegna showing Venus and Mars ruling over the muses on Mount Parnassus, Isabella did not provide such specific instructions. The result was that some beholders apparently misinterpreted the painting by assuming that Isabella herself was portrayed in the figure of Venus who, although clearly supposed to be very beautiful, was also depicted completely in the nude – not at all appropriate for a high-ranking lady very concerned about her public image. Thus, Isabella's concern with keeping her artists on a short leash was linked to the fact that, as a woman patron, she had to be particularly careful to commission artworks that would not cause her any scandal or embarrassment.

The problems of devising appropriate images for a female patron were perhaps even more acute for Queen Elizabeth I of England, who was neither a wife nor a widow, but rather that most exceptional thing of all: a single woman who was rich and powerful all on her own. Elizabeth was nevertheless preoccupied with how to use images effectively and appropriately to confirm her legitimacy as the rightful, Protestant heir of her father, Henry VIII, while also striking the right balance between asserting her power and avoiding the negative connotations Renaissance culture associated with women who tried to rule over men. Not surprisingly, some of the

most important images she commissioned in the first part of her reign after succeeding her Catholic half-sister Mary in 1558 made very clear references to her father and the Tudor dynasty. For example, in a painting known as the *Allegory of the Tudor Succession*, Elizabeth is led to her enthroned father by goddesses symbolizing Peace and Plenty, flanked by Henry's by then deceased son Edward, thus visually confirming her as Henry's legitimate and divinely ordained heir.

Elizabethan imagery changed from the early 1580s onwards, when it became clear that the Queen, by then in her late 40s, would probably never marry and, more importantly, would never produce her own heir to the throne. It was at this time that she began to encourage her courtiers to commission paintings that portrayed her more and more explicitly as a chaste, ever-virgin, and always youthful queen. Like Catholicism's favorite virgin saint, the Madonna, whose cult the Protestant Elizabeth in some ways tried to replace with her own, the Queen is portrayed in a painting attributed to Marcus Gheeraerts the Younger as a quasi-religious figure dressed in virginal white and wearing long strands of pearls, both symbols of chastity (Figure 24). In this portrait, Elizabeth also literally stands on a map of England, echoing the commanding, iconic presence her father had assumed in his own full-length portraits.

Interestingly enough, in most cases, the Queen herself didn't actually pay for or commission such paintings, instead encouraging her courtiers to serve as paymasters. For this particular portrait, the courtier in question was probably Sir Henry Lee, owner of a grand estate in Ditchley in the county of Oxfordshire. Significantly, Elizabeth stands in this portrait with her feet firmly planted on precisely this county, and we know from documents that she even visited Ditchley in 1592, possibly the occasion that sparked her devoted courtier to commission the painting in the first place. In this image, the patron and painter also made sure they used one of

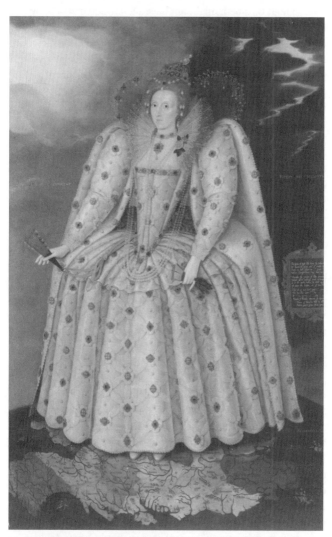

24. Marcus Gheeraerts the Younger (attr.), *Queen Elizabeth I of England* (*The Ditchley Portrait*), c. 1592

Elizabeth's officially approved templates for the monarch's face. So, even though Elizabeth might not have actually handed out any cash for this particular portrait, her ultimate control over such projects in terms of their style and iconography, coupled with the fact that the Queen encouraged multiple replicas to be made of her favourite portrait types, suggests that such commissions were part of a coordinated strategy to use visual means to confirm her power over her courtiers and over the land she ruled for five decades.

Women as artists

Women, however, were not just the subjects and patrons, directly as well as indirectly, of works of art in this period. For it is in the later 16th century that we also begin to see for the first time professional women artists working mainly as painters. Perhaps the earliest known example of this phenomenon is the Bolognese painter Lavinia Fontana, whose father Prospero was also an artist who may well have decided to have his daughter follow in his footsteps because he did not have a son to inherit the family business. As a woman working in what was very much a man's world, Lavinia would have encountered numerous difficulties, but she would have also gained some advantages from this unusual situation. So, while she was probably unable to study the male nude from life for reasons of propriety and decorum, thereby missing out on a key aspect of artistic training in this period, she may well have compensated for this by copying classicizing statuettes of male bodies, as suggested by the small sculpted figures included in one of her self-portraits. She also seems to have exploited her status as a 'wonder', an exception to the generally held rule of female inferiority in this period, in order to foster a demand for her skilfully executed paintings. At the same time that she produced portraits of male academics, prelates, and aristocrats, as well as some large-scale religious works, Lavinia seems to have deliberately created a kind of niche market in images made of and for well-to-do women patrons who would have felt particularly comfortable working with an elegant young woman artist, once again suggesting

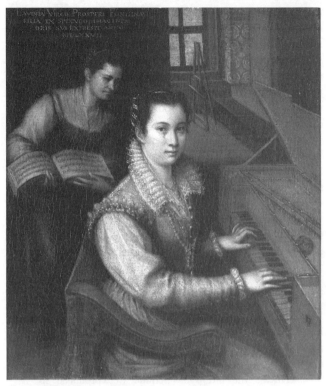

25. Lavinia Fontana, *Self-Portrait with a Maidservant, Keyboard, Easel, and Cassone*, 1577

that gender, properly exploited, could sometimes be a positive advantage for a woman painter in this period.

Lavinia's success was thus as much about creating a public image as a unique, refined, and talented woman artist as it was about the skill and innovation actually displayed in her paintings. This very conscious self-fashioning was visually documented in her numerous self-portraits, including one showing her beautifully dressed and seated like a proper gentlewoman at a clavichord with a maidservant at her beck and call (Figure 25). This painting

may well have also played an important role in the preparations made in anticipation of her marriage in 1577 to a relatively poor but aristocratic young man. The painting was executed by Lavinia and sent to her future in-laws in order to assure them of her social graces, pleasing appearance, and many accomplishments, all necessary attributes for a bride intended for a gentleman of good breeding. Furthermore, the self-portrait could have helped to convince her future husband that she fully intended to uphold her side of the marriage contract, which entailed her contributing to the family's economic well-being through her art. Significantly, Fontana's self-portrait includes an easel and a *cassone* – the one a tool of her trade, the other a piece of furniture generally associated with marriages and dowries. Without a dowry herself, Fontana was thus demonstrating to her husband and his family by visual means that she possessed a valuable talent that could stand in lieu of – and perhaps could even surpass – a cash dowry.

Conclusion

Looking at such paintings – those of women, both real and imagined, and artworks commissioned by or for women patrons – from the point of view of gender allows us to gain a much more sophisticated understanding of both the images themselves and the culture in which they were produced. So, while we can continue to debate whether women in general actually had a 'Renaissance' during the Renaissance, there is no doubt that considering the art of this period in terms of gender provides us with new insights, as well as forces us to start asking new questions.

Chapter 7
Objects and images for the domestic sphere

The Renaissance interior

Although many museums and guidebooks seem to imply that
Renaissance art consists only of monumental masterpieces
by well-known artists, this chapter will remind us that the
vast majority of works produced in this period were actually
smaller-scale objects made by little-known or even anonymous
artists and craftsmen for specific domestic or devotional purposes.
Inventory descriptions and paintings of interiors such as those seen
in Jan van Eyck's *Arnolfini Portrait*, Mary of Burgundy's *Book of
Hours*, the Master of Frankfurt's *Portrait of an Artist and H'u Wife*,
Holbein's *Ambassadors*, or on the far right side of Carpaccio's
Arrival of the English Ambassadors and St Ursula with her Father
remind us that wealthy Renaissance men, women, and children
would have been surrounded in their homes by a wide variety of
more-or-less functional decorated and decorative objects (see
Figures 8, 9, 13, 19 and 21). Listing a few of these belongings gives
us a sense of just how visually and texturally rich the interior of a
Renaissance palace, château, or wealthy citizen's townhouse could
be: silver cutlery and platters; brightly glazed ceramics; glittering
glassware; luxurious hanging tapestries; colourful rugs imported
from the Orient; fine bed linens and velvet curtains; hand-woven
and embroidered wool, silk, brocade, and lacework clothing;
precious jewels mounted in gold and silver settings; richly

illuminated manuscripts and, from the later 15th century onwards, illustrated printed books in textured leather bindings; painted panels and canvases; elaborately framed mirrors; bronze and marble statuary (such as the bronze statuette of the Apollo Belvedere that once belonged to Isabella d'Este [see Figure 15]); glowing candelabra; ancient coins and newly minted commemorative medals; beautifully crafted scientific and musical instruments; inlaid wooden panels known as *intarsia*; and decorated beds, benches, and other types of movable furnishings. Some homes even had walls covered in embossed leather or painted with ornamental frescos.

Today, some of the objects originally found in the homes of wealthy Renaissance patrons are proudly exhibited on the walls of our galleries as works of 'Art', while others are displayed in special rooms or even separate museums devoted to the decorative arts and shown as examples of more lowly craft production. But 15th- and 16th-century beholders would probably not have made such clear-cut distinctions. Sandro Botticelli's *Primavera* (*Spring*) is a telling example of how what we now think of as an artistic 'masterpiece' might have been viewed in quite a different light by its original Renaissance beholders (Figure 26). Although today we would consider this painting to be priceless, its later 15th-century beholders might well have seen it instead as a relatively cheap alternative to much more expensive tapestry wall hangings, a suggestion supported by the fact that the painting's composition recalls Renaissance tapestry designs that likewise had frieze-like groups of figures set against flat, decorative backgrounds filled with fruit, flowers, and foliage. The fact that the *Primavera* may have been commissioned for the wedding of a member of the Medici family also suggests that its complex iconography may be related to the long-standing tradition of using appropriate allegorical and symbolic images on items made for births and marriages. This was a practice also deployed in the decoration of

26. **Sandro Botticelli,** *Primavera,* **tempera on panel, c. 1478**

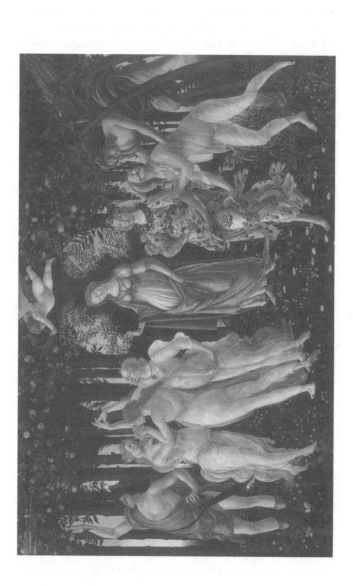

other types of household objects and furnishings, which today we might not consider as being in the same league in aesthetic terms as the *Primavera*, but which Renaissance beholders would have understood as being part of an iconographic continuum related to the dynastic concerns implicit in matrimony and childbirth.

A brief examination of some of the key elements of the *Primavera* supports such an interpretation. Near the centre of the composition, we see the goddess of love, Venus, with blind-folded Cupid flying above her head, about to shoot an amorous arrow. On the right, a pale blue male figure representing the cold North Wind tries to grab a woman, possibly intended to represent Spring and sprouting flowers from her mouth. The female figure beside her may show Spring once again, but now free from the wintery Wind's clutches and positively bursting with flowers. On the left, Mercury, messenger of the gods in Classical mythology, and the beautiful Three Graces dancing in a circle complete the scene. Although the precise meaning of this complicated composition continues to be debated by scholars to this day, the fact that several of the figures seem to be related to the themes of love, fertility, and beauty suggests that the image may have been specially designed for a newly wed couple keen to celebrate their marital union and to ensure that they would produce many beautiful and healthy children.

Other items in the homes of the wealthy were also 'customized' to reflect the interests and concerns of their owners. For instance, the Medici, patrons of Botticelli's *Primavera*, also ordered a splendid two-handled glazed terracotta jar from an unknown craftsman working in the Valencia region of Spain (Figure 27). The piece's beautiful iridescent finish, known as 'lustre', was made by using a technique that had originally been developed by Islamic artisans, but had then been adopted by Spanish ceramicists in the 15th century and, after 1500, was used in Italy as well. We know that this particular example dates from the second half of the 15th century

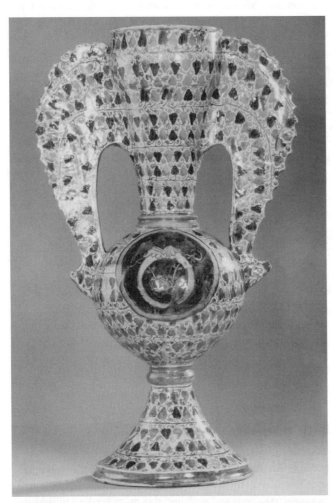

27. Unknown Valencian ceramicist, *Wing-handled jar decorated with leaf motif and Medicean heraldic symbols*, lustred earthenware, c. 1465–92

since it includes the coat of arms of either Piero de' Medici (d. 1469) or his son Lorenzo (known as 'The Magnificent', d. 1492) on one side. On the other side, seen in the present reproduction, additional Medici family emblems are visible, including a diamond ring, which alludes to eternity, depicted in the centre of the jar against a dark blue ground. The rest of the piece is decorated with what may be vine leaves, most appropriate if the jar was used to dispense wine at a Medici family feast. Even when not in use, however, the familial symbols and the jar's evident cost and beauty could have been appreciated by visitors, since the object probably would have been openly displayed in one of the family's palaces.

In the case of a richly gilded *cassone* made in c. 1455–65 (Figure 28), the coats of arms of two other Florentine families can be seen embedded within the decorative pilasters on the left and right sides of the chest, specifically, those of the Spinelli and, possibly, Tanagli families. This suggests that the object was made on the occasion of a wedding between members of these two clans. Such chests often included painted images that attested to their patrons' erudition (for instance, by depicting scenes from ancient history or Classical mythology), had allegorical or symbolic links to marriage (as seen in illustrations of the Triumph of Chastity), or familial significance (as in the scene found on the present *cassone* of a tournament on the square of S. Croce in Florence, located not far from the Spinelli family's palace).

Birth, marriage, and Marian reliefs

Coats of arms of two families joined in marriage were also often added to the frames or bases of sculpted images of the Madonna and Child, such as the example shown in Figure 29, possibly designed by Lorenzo Ghiberti and reproduced in many versions throughout the 15th century. Marian reliefs in general form one of the largest surviving categories of art objects from Renaissance Italy. Indeed, it

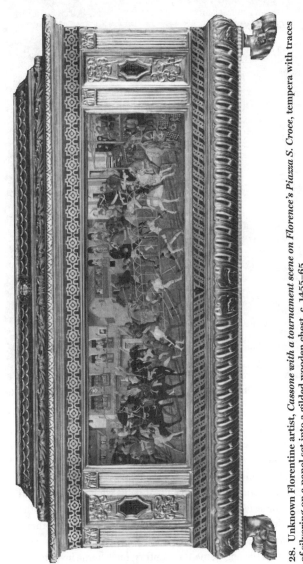

28. Unknown Florentine artist, *Cassone with a tournament scene on Florence's Piazza S. Croce*, tempera with traces of silvering on a panel set into a gilded wooden chest, c. 1455–65

29. Lorenzo Ghiberti (design), *Madonna and Child*, painted terracotta, c. 1420s–30s

is estimated that over 1,000 examples survive to this day. Most art historians have concentrated on using stylistic criteria to categorize these works primarily in terms of artists' names and dates of production in order to establish a reliable corpus of authentic objects – a serious concern given that many copies, replicas, and outright forgeries of these types of reliefs were made in the 19th and early 20th centuries. Such issues were not, however, those that would have most concerned the original beholders of these works. Indeed, until the end of the 15th century, most home inventories did

not bother to specify the authorship of such objects, which suggests that questions of attribution were not of primary importance to their first owners. It is only by taking these reliefs out of the context of traditional art historical scholarship and re-inserting them into their original viewing circumstances that their full cultural significance can begin to emerge.

The most obvious function of such reliefs was clearly devotional. But devotion itself, including some of its rituals and practices, was slowly changing in this period. For instance, one can document an increasing intensity in Marian devotion from the 12th or 13th century onwards, coupled with a new emphasis on promoting lay (as opposed to clerical) piety. The cult of the Virgin and growing interest in lay piety converged in a desire to humanize Christ and the Madonna in new kinds of texts, images, and devotional practices. Paintings depicted sacred figures as increasingly interactive beings, with the humanity of Jesus and Mary emphasized through new iconographic types such as the Holy Family or the Madonna nursing the Christ Child. New devotional texts also encouraged readers to empathize with Christ and the Virgin. In some cases, devotees even began to have mystic experiences in which they actually took on the roles of the Madonna or Christ himself. Some of these visions may have been triggered by objects rather than by texts alone, as in the case of life-size, wooden Christ Child dolls from the early Renaissance. St Francis, for instance, described a miracle in which such a doll displayed in a Christmas Nativity scene seemed to come alive in his arms. Other documents confirm that women, including nuns, likewise sometimes imagined that they had turned into the Virgin Mary, with the doll in their arms similarly transformed into the real Christ Child, suckling at the breast.

This type of empathetic piety, coupled with a proliferation of humanizing images of the Madonna and Child, were important influences on the development of the Marian relief in the

15th century. Although these reliefs took up themes found in painted images as well, the particular qualities of sculpture as a medium subtly changed the relationship between image and beholder. Indeed, compared to a painting, the distance between sacred figures and their beholders was reduced since these objects could now become three-dimensional beings co-existing in the same physical and psychological space as their beholders. The fact that some of these works seem to have been handled as though they were real flesh and blood beings, for instance by having real clothing or jewellery placed on them, lends further support to such an interpretation. Brightly painted high-relief terracottas depicting the Madonna and Child would have been particularly efficacious in encouraging a very corporeal type of devotion. It is this type of art that the 15th-century theologian Fra Giovanni Dominici may have had in mind when he recommended that parents display sacred images for their children to contemplate:

> ... in the house [have images] in which your child when still in swaddling clothes may delight as being like himself The Virgin Mary is good to have with the child on her arm A good figure would be Jesus suckling, Jesus sleeping on his mother's lap, [or] Jesus standing politely before her.

This suggests that the kind of Marian imagery this particular writer had in mind was intended primarily for relatively unsophisticated or even uneducated beholders, including women and children.

Inventories of the 15th century confirm that Marian reliefs in general were most often displayed in bedrooms. However, in this period, bedrooms were much more than just places to sleep. Indeed, in many ways, the bedroom was the symbolic heart of a household, as seen in the *Arnolfini Portrait*, in which the couple receive visitors in a room with a canopied bed, or in Carpaccio's painting of St Ursula discussing her marriage prospects with her father, which also features a similar piece of furniture as well as a framed image of

the Madonna and Child in paint or possibly low relief. Paintings, prints, and home inventories suggest that bedroom images of the Madonna and Child often had holy water receptacles or candelabra placed before them. Other marks of respect included hanging real jewellery or clothing on these reliefs, as mentioned above, as well as concealing them behind protective curtains or shutters.

Although the primary function of such objects would have been to serve as aids to devotion in the domestic sphere, these works also may have served needs that were less strictly religious. Specifically, such images may have played an important role in addressing Renaissance concerns about birth and marriage. An important clue to these other functions of Marian reliefs is found in the purchasing patterns of wealthy Florentines. Like present-day couples 'registering' at a big department store in anticipation of their wedding, Renaissance couples also went on a shopping spree before their marriage, when the groom redecorated the marital bedroom in particular by purchasing new furnishings and art objects. Some of the items bought at this time included *cassone* decorated with fashionable historical, mythological, or allegorical subjects; *deschi da parto*, or birth-trays used to bring refreshments to new mothers resting in bed; and, significantly, paintings and reliefs of the Madonna and Child. Such objects obviously had a practical function in that they could store precious textiles, carry food and drink, or act as a focus for daily devotional prayers. But they also could serve less obvious pedagogical or talismanic purposes, such as seeking to reinforce contemporary beliefs about appropriate female behaviour, as suggested by images of the Triumph of Chastity painted on some *cassone*, or magically ensuring that a healthy male heir would be born to continue the paternal line, as we shall see below.

Renaissance marriage rites in general, as well as the objects purchased at the time of a wedding, often focused quite explicitly on symbolically linking a new couple's families and asserting the groom's dynastic ambitions. The bonds between husbands and wives were given permanent visual form by emblazoning both

30. Bartolomeo di Fruosino (attr.), *Birth-tray with seated nude boy*, **tempera, gold and silver on panel, 1428**

families' coats of arms on many of the items bought for weddings and births, including *cassone*, birth-trays, and Marian reliefs. In addition to such literal familial iconography, the groom's dynastic aspirations may also have been alluded to in the figurative components of Madonna and Child reliefs, specifically, in the figure of the Christ Child himself. Renaissance culture generally placed a very high value on the birth of male children to continue the paternal line. Perhaps not surprisingly, depictions of male children are often found on objects related to birth and marriage, for instance in the Christ Child seen in Marian reliefs or in the images of young boys painted on birth-trays like the one illustrated in Figure 30. The talismanic or magical functions of such objects are

confirmed by the inscription found on this particular *desco da parto*, which alludes to the good fortune of having a male child and seeks to protect women from the perils associated with giving birth.

How such images were believed to 'work' by their original owners is best explained by contemporary ideas about sympathetic magic and the power of the maternal imagination, ideas that can be traced back to antiquity. A 4th-century text neatly sums up the concept: 'the foetus is formed by the imagination of the woman during conception; for often images and statues are desired by women, and they bring forth similar progeny'. So, simply by having a young bride look at a painting or, even better, a three-dimensional sculpture of an idealized male child at the moment of conception or during pregnancy, it was believed that she would then give birth to similarly perfect and, equally important, male offspring to continue her husband's family line. The fact that appropriate images of beautiful young boys were often located in bedrooms would, presumably, have been particularly convenient.

Thus far, we have considered Marian reliefs in terms of contemporary devotional practices and their use as talismanic objects associated with birth and marriage. There is, however, yet another way to approach these images, namely, as works of art. However, it is only towards the end of the 15th century that one can begin to detect an interest in judging such works primarily as aesthetic objects. For example, it is only in an inventory taken of the contents of the Medici Palace in Florence in 1492 that we find for the first time the name of a specific artist, in this case Donatello, being associated with specific Marian reliefs, with such objects now listed as being stored in the *studiolo* with other works of art, books, and ancient artefacts, rather than hung on a bedroom wall for primarily devotional or talismanic purposes. Even in this inventory, however, the vast majority of such reliefs continue to be listed without any attribution whatsoever and continue to be displayed in bedrooms. Of course, 15th-century patrons were

certainly not oblivious to the aesthetic qualities of such reliefs. Indeed, the existence of so many different types of Marian reliefs, in terms of quality, design, and medium – examples exist not only in painted terracotta, but also in marble, bronze, plaster, and glazed terracotta – suggests that many 15th-century beholders were sensitive to such issues. However, until the last years of the 15th century, most patrons probably would not have seen the majority of these objects first and foremost as works of art in the way we understand the term today.

New genres for the domestic sphere

The growing popularity of Marian reliefs in 15th-century Italy finds a parallel in the rise of other new artistic genres in this period that were also made primarily for display in the domestic sphere. As we saw in Chapter 5, independent painted portraits became increasingly popular for an ever-widening clientele in Italy and, especially, Northern Europe from the early 1400s onwards. A more expensive option, first developed in Italy, was the marble and, later, bronze portrait bust. The former medium especially would have reminded contemporary beholders of Classical prototypes, while at the same time asserting the long-term dynastic ambitions of families like the Medici and Sassetti, for whom marble portrait busts were carved to be proudly displayed in their grand urban palaces and which they must have hoped would survive for as long as those of their ancient Roman predecessors.

In Northern Europe, other secular art forms likewise intended primarily for domestic display emerged in the 16th century, in part in reaction to the pressures of the Reformation, with its hostility to devotional images of all types. In particular, landscape begins to emerge as an independent genre in the early 1500s in the work of artists like Dürer and Albrecht Altdorfer. Slightly later, paintings of everyday life known as 'genre scenes' begin to be commissioned and

31. Pieter Brueghel the Elder, *The Fall of Icarus*, oil on canvas, c. 1555

collected as well. Although landscapes and genre scenes with absolutely no discernible narrative were painted, drawn, and printed in the 16th century, many such images, especially when painted in oil, often had a kind of secondary or subsidiary subject matter that becomes evident only upon closer inspection. For instance, the mid-16th-century Flemish artist Pieter Brueghel the Elder painted a work entitled *The Fall of Icarus* that incorporates both a typical scene of country life, in which a farmer ploughs a field in the foreground, with a spacious land- and seascape that seems to continue as far as the eye can see (Figure 31).

If one examines Brueghel's painting attentively, however, one eventually notices a tiny pair of white legs flailing about in the blue-green sea in the lower right corner of the composition, between the ship closest to the picture plane and the shoreline. This, as the work's title suggests, is Icarus, son of the ancient Greek artist-engineer Daedalus who designed for himself and his child each a pair of enormous wings, with which they flew out of captivity on the island of Crete. Despite his father's warnings, however, the impetuous Icarus, convinced he could soar up to the gods themselves, flew higher and higher until, at last, he was so close to the sun that the wax holding together the feathers of his wings melted, sending him plunging down into the sea below to drown, an enduring symbol of overweening ambition and pride (literally) coming before a fall.

Brueghel's source for this tragic tale, which gives an enigmatic narrative focus to his landscape-genre painting, was the ancient author Ovid. In a poem of 1938 entitled 'Musée Des Beaux-Arts' after the Brussels museum where the painting now hangs, W. H. Auden eloquently described the apparent incongruity of such epic, mythic events intruding on everyday life:

> About suffering they were never wrong,
> The Old Masters: how well they understood
> In Brueghel's *Icarus*, for instance: how everything turns away

Quite leisurely from the disaster; the ploughman may
Have heard the splash, the forsaken cry,
But for him it was not an important failure; the sun shone
As it had to on the white legs disappearing into the green
Water, and the expensive delicate ship that must have seen
Something amazing, a boy falling out of the sky,
Had somewhere to get to and sailed calmly on.

Conclusion

In Renaissance Europe, images of mythological figures such as
Venus or Icarus, and Classical genres like the marble portrait bust
or the bronze statuette, seem to have happily co-existed in the
domestic sphere with the familial and devotional paraphernalia
of everyday life, from Marian reliefs and hanging tapestries to
decorated storage chests and wine jugs. Today, museums generally
tend to keep such 'high' and 'low' artefacts separate from one
another, but for wealthy 15th- and 16th-century beholders, these
objects would simply have been part and parcel of their daily lives.

Chapter 8
The story of a square: art and urbanism in Florence

Setting the scene

The study of Renaissance art should not be limited to looking at a series of autonomous, individual works isolated on the walls of a museum or on the pages of a textbook, but rather should be an exploration of the complex interactions between objects and the places, patrons, beholders, and historical circumstances that defined their original contexts. In previous chapters, we have explored Renaissance paintings, sculptures, and other items of visual and material culture made for churches, chapels, palaces, and the domestic sphere. In this chapter, we will step outside into the streets and squares of Florence in order to consider how large-scale public sculpture could also be actively integrated into the lives and concerns of 15th- and 16th-century beholders.

Specifically, we will focus on one public square in particular, Florence's Piazza della Signoria. This square, carved out of the medieval city centre and dominated by the imposing town hall, is still one of Florence's most important civic spaces and, in many respects, remains essentially unchanged from how it looked during the Renaissance, as seen in an early 16th-century painting of the piazza by an unknown artist (Figure 32). Here, we see on the right the town hall with its

32. Unknown Florentine artist, *The Execution of Girolamo Savonarola in 1498 on Florence's Piazza della Signoria (with the 'Marzocco' and 'Judith' in front of the town hall)*, oil on panel, early 16th century

tall watchtower and the ceremonial raised platform known as the *ringhiera* running along its front. Further to the right, a *loggia*, or vaulted arcade with three open bays, is depicted, while on the far left edge of the composition, we can just make out part of the great dome of Florence's Cathedral, completed in 1436 by Brunelleschi, as discussed briefly in Chapter 4. More disturbingly, at the centre of the square, we see a burning pyre linked by a temporary walkway to the front corner of the town hall. Above the flames, a few small figures dangle from a tall post. These are the radical Dominican cleric Fra Girolamo Savonarola and his companions, who were executed at this very spot in 1498. This traumatic event was the impetus for producing this view of the square, but for our purposes, the space, architecture, and statuary recorded in this image are of primary importance, rather than the gruesome end met by the over-zealous friar.

During the half century between the establishment in Florence of a patrician-dominated regime in 1382 and the rise of the Medici family in the 1430s, an ambitious programme of urban planning and civic statuary was undertaken around the governmental and religious centres of the city. The streets and squares around both the town hall and the Cathedral were widened and regularized, the sculptor Ghiberti produced two massive decorated bronze doors for the city's Baptistry, and more than two dozen life-size statues by artists such as Donatello and Nanni di Banco were prominently installed on key buildings in central Florence, an enterprise that in its scope and variety had probably not been seen in Europe since antiquity. The origins of most of these structural and sculptural programmes, however, can be traced back to the later 13th and 14th centuries, that is, well before the new oligarchic regime came to power in 1382.

The lion on the piazza

In contrast, the very first statue that this new government seems to have commissioned was made for an important civic site with no significant pre-existing sculpture, the Piazza della Signoria, where the recently completed *loggia* and the town hall that housed the patrician rulers known as *signori* were located. This new statue was a fully gilded stone sculpture depicting Florence's symbolic lion, the so-called *Marzocco*, which was placed on the corner of the ceremonial platform in front of the town hall. The original, late 14th-century *Marzocco* is lost, but its appearance can be determined from later paintings and frescos. In fact, if we look very closely at the painting of the execution of Savonarola, we can just make out this sculpture standing at the point where the temporary walkway joins the *ringhiera* at the front corner of the town hall. Such images suggest that the *Marzocco*'s basic design was quite similar to a stone statue carved by Donatello in 1419 that eventually replaced the first *Marzocco* in front of the town hall. Donatello's lion crouches on its hind legs proudly holding a shield in its right front paw decorated with Florence's symbolic flower, the lily. Instead of a

shield, however, the original *Marzocco* may have crouched over a wolf, possibly intended to represent Florence's long-time rival, Siena.

The century before the original *Marzocco* was placed in front of the town hall was a turbulent era in the political, social, and economic history of Florence. Bankruptcies, revolts by the labouring classes, conflicts with the papacy in Rome, brief periods of tyrannical rule, outbursts of religious fanaticism, and, in 1348, the coming of the great plague known as the Black Death made the 14th century a time of conflict and anxiety for many Florentines. These tensions culminated in the so-called Ciompi Rebellion of 1378 in which wool industry workers known as *ciompi* staged a coup and briefly ruled the city together with other members of the poorer guilds. This regime was, in turn, overthrown in 1382 by a new coalition of wealthier guildsmen and the city's patrician elite. By the early 15th century, the city was effectively being run by a small inner circle of patricians and leading members of the wealthiest guilds that included, among others, the bankers, cloth merchants, and wool and silk entrepreneurs. It was under the direct and indirect supervision of this elite that the statue of the *Marzocco* in front of the town hall and, in the first decades of the 15th century, over two dozen other large statues were prominently installed in the governmental and religious heart of Florence.

The principal approach to the *Marzocco* was from the corner of the Piazza della Signoria diagonally opposite the statue, where a beholder coming from the front of the Cathedral by the most direct route would have entered the square – in the view of the square on the day of Savonarola's death, this corresponds to the lower left corner of the composition where we see a man on horseback entering the piazza. The importance of this approach to the town hall is underscored by the concerted efforts made in the later 1380s to widen and regularize the street connecting the town hall and Cathedral. Although the street wasn't fully widened along its entire length until the 19th century, documentary evidence suggests that

the city's rulers had originally planned to do so already in the later 14th century and had hoped to coordinate the style of the façades of the Piazza della Signoria, the buildings along the connecting street, and the structures surrounding the Cathedral, thereby fully integrating the centre of the city into a visually unified complex encompassing Florence's main civic and religious spaces. By placing the *Marzocco* at the visual and symbolic focal point, or apex, of the newly emphasized oblique approach to the town hall, the *signori* would have focused the attention of the citizenry on their own power and authority as symbolized by the lion of Florence, the town hall behind it, and, implicitly, the rulers themselves who inhabited this building and who were also regularly displayed in front of it during ceremonies held on the *ringhiera*.

The symbolic links between Florence's rulers and the *Marzocco* also extended well beyond the city walls. In fact, throughout the 15th century, insurgents in Florentine territory and rival powers in central Italy equated Florence and its rulers with this lion. The Bolognese, for example, burned straw *marzocchi* in their central square to protest against the Florentine government's interventions into local affairs, and the Pisans, after retaking control of their city from Florence, toppled a lion statue installed by the Florentines, dragged it through the city streets, and then finally threw it into the Arno River. The Florentines themselves were well aware of the significance of the *Marzocco* image and thus placed painted and sculpted copies of this statue in the main squares of other towns under their control. The significance of this iconography was appreciated even in the Florentine countryside, as suggested by a notorious incident in which local villagers decapitated a donkey dressed up as the *Marzocco* in order to express their anger towards their big-city masters. Whether displayed on the Piazza della Signoria or in towns under Florence's domination, the *Marzocco* thus effectively became a permanently present and ever-vigilant symbol of the Florentine government, indeed, in certain respects, interchangeable with the *signori* themselves.

Sculpted idols and ideals

For the rest of the 15th century, no major new statuary was commissioned for the town hall square, perhaps emblematic of the fact that this was a period during which the powers of the *signori* declined at the expense of the growing dominance of one family in particular, the Medici, who by mid-century had effectively become the autocratic rulers of the city. Under Lorenzo de' Medici – known as 'The Magnificent' for his leadership style and lavish support of the arts – Florence entered a brief but glorious golden age in the second half of the century. However, things fell apart soon after Lorenzo's death in 1492 and, in 1494, the Medici were overthrown and expelled from the city by a new coalition of broadly republican forces. Less than a year later, in 1495, Donatello's bronze statue of *Judith decapitating Holofernes* (Figure 33), which had once adorned the garden attached to the Medici family's grand city-centre palace, was confiscated by Florence's new rulers and placed in front of the town hall on the *ringhiera*, not far from the *Marzocco* – one can just make it out in the painting of Savonarola's execution. The statue was an immensely ambitious project, given how complicated it must have been to cast successfully a life-size pair of figures mounted on an integrated triangular base decorated with relief scenes – see, for instance, Cellini's dramatic description of the dangers and difficulties involved in casting such a work, as discussed in the first chapter.

When it was originally displayed in the Medici Palace, the statue was meant to be understood as a fairly generic allegory of virtue triumphing over vice. However, once it had been moved into its new physical and political context, and a new inscription had been added, its meaning shifted to a pointedly anti-Medicean allusion to the victory of republicanism over autocratic tyranny. The iconographic implications of the story of Judith must have seemed particularly appropriate to the new government given

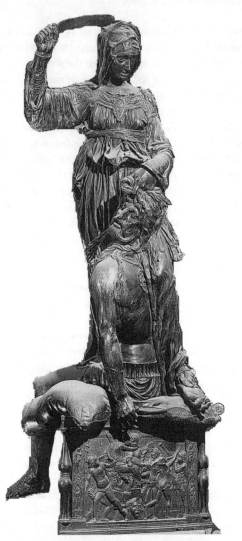

33. Donatello (Donato di Niccolò di Betto Bardi), *Judith decapitating Holofernes*, bronze, mid-15th century

the political circumstances of 1494–5. Judith, the chaste Jewish widow who had saved her people by decapitating the dissolute tyrant Holofernes, would have been an opportune symbol of the new government's claims to moral superiority in comparison to the corruption and arrogance associated with the last years of Medici rule in the 15th century. Like Judith, who overcame the perceived limitations of her sex by acting like a man while slaying her enemy, the new government had also overcome great odds in order to triumph over the powerful Medici family and its allies. Significantly, Donatello's composition shows the very moment when Judith has triumphantly raised her sword to strike the final blow that will sever the head from the general's slumped body. By relocating this dramatic composition to the *ringhiera* by the town hall's main entrance, and by redefining its civic significance through a new inscription, Florence's rulers had transformed a Medicean idol into a republican ideal.

But the government's decision to appropriate the *Judith* for its own political purposes soon ran into an important obstacle, namely, the gender of its newly adopted heroine. Less than a decade after the bronze had been installed on the *ringhiera*, the *Judith* was literally and metaphorically removed from the symbolic centre of Florentine civic life and replaced by Michelangelo's colossal marble *David* (Figure 34). In January 1504, a gathering of citizens debated at length about where to place the recently completed *David*, which was originally made to be set high above ground level on one of the Cathedral's buttresses. The first speaker at this meeting was an official representative of the new government, the palace herald, a certain Messer Francesco. Presumably reflecting the attitudes of at least some members of the government, he stated that:

> ... the Judith is a deadly sign and inappropriate in this place because our [that is, Florence's] symbol is the cross as well as the lily, and it is not fitting that the woman should slay the man, and, worst

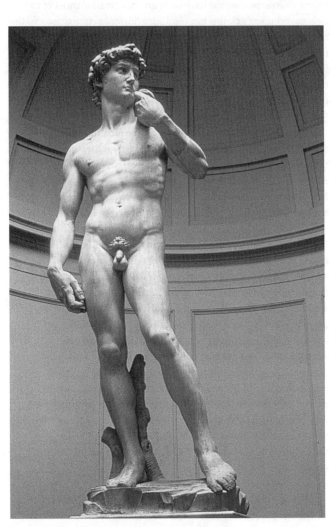

34. Michelangelo Buonarroti, *David*, marble, 1504

of all, it was placed in its position under an evil constellation because, since then, things have gone from bad to worse, and Pisa has been lost.

By evoking the familiar Early Modern *topos* of the dangerous power of women who seduce and then slaughter unsuspecting men, Messer Francesco suggested that the town's recent misfortunes, including the loss of Pisa, a city it had formerly ruled, could be blamed on the decision to display an inauspicious image of such a dangerous woman in a public place.

The obvious solution was to reposition the statue that had so profoundly disrupted the patriarchal order in which man is assumed to rule over woman. Indeed, the decision to replace the *Judith* with Michelangelo's *David* would have provided the new government with a much less disturbing, but equally appropriate, allegory for the republican triumph over Medicean tyranny. Like the tale of Judith, the story of David also involved a most unexpected hero, in this case a mere shepherd boy, beating the odds to overcome another evil monster, the wicked giant Goliath. And so, Michelangelo's iconic sculpture was installed in front of the town hall, with Donatello's statue removed from the eyes of the general public by being placed inside the building. Two years later, in 1506, the *Judith* was once again allowed to be displayed on the Piazza della Signoria, but now her symbolic deference to the triumphant *David* was confirmed by her placement under the far left arch of the *loggia*, a much less charged location than on the *ringhiera* by the town hall entrance where Michelangelo's statue now stood.

In 1554, nearly half a century after the *Judith* had been reinstalled on the square, she was provided with a pendant figure also made of bronze. But this new sculpture, Cellini's *Perseus holding the head of the Medusa* (Figure 35), completely reversed the 'woman on top' theme of *Judith decapitating Holofernes*. Instead, in the

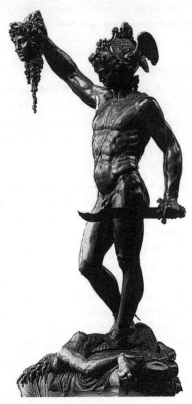

35. Benvenuto Cellini, *Perseus holding the head of the Medusa*, bronze statue on a marble and bronze base, 1545–54

Perseus (whose making Cellini described in the passage quoted in Chapter 1), it was a man who was depicted standing on top of a decapitated female body holding aloft in one hand the Medusa's gory head, which had previously turned any man who dared to look at it into stone. Cellini's disturbing composition would therefore have been much more in keeping with the dominant patriarchal ideology of the period.

Conclusion: the return of the Medici

Cellini's statue, together with several other marble mythological figures, had been commissioned by Duke Cosimo de' Medici after the family's enormously successful return from exile in 1512. By 1575, an imposing fountain crowned by a statue of Neptune had been installed by the Medici at the corner of the town hall that was still a key focal point of the square, thereby literally replacing the *Marzocco* that recalled the pre-Medicean era with a work of the family's own choosing. It would have been much more difficult to remove works such as the *Judith* or the *David*, despite their even stronger republican associations, since, by the mid-16th century, these statues and the artists who had made them were esteemed far and wide as some of the most spectacular examples of Florence's amazing artistic heritage. So, rather than unceremoniously removing these sculptures, the Medici chose instead to recontextualize all the statues on the square by commissioning numerous new works by other famous artists of the day, including, among others, Cellini and, later, the Flemish-born sculptor Giovanni Bologna (also known as Giambologna).

By effectively turning the Piazza della Signoria into a vast outdoor sculpture gallery, the troublesome iconographic implications of the earlier statues would thus have been transformed from anti-Medicean republican propaganda into aesthetically pleasing works of art that attested to Florence's and, by implication, the Medici family's wealth, taste, and artistic brilliance. The square, in other words, had by the later 16th century itself become a work of art, a status it maintains to this day, overrun by tourists eager to see some of the 'greatest hits' of Renaissance sculpture gathered in one compact piazza. However, only by carefully considering the changing physical and historical circumstances of the square and the statues displayed within it can we begin to appreciate more fully the links that inevitably bind the meanings of such works to their surroundings, both spatial and temporal.

Chapter 9
Michelangelo: the birth of the artist and of art history

New ideas about 'Art' and artists

Thus far, we have considered Renaissance art primarily in terms of
its location, medium, function, genre, composition, iconography,
patrons, and beholders. But the man who was probably the world's
first proper art historian, the 16th-century painter Giorgio Vasari,
organized *his* survey of Renaissance art around the biographies
of individual artists presented in chronological order, thereby
constructing an artistic canon and shaping the very discipline of art
history in ways that are still pervasive this day. Indeed, it was only
during the Renaissance itself, in large part under the influence of
Vasari and the artist he most admired, Michelangelo, that many of
our most fondly and firmly held assumptions about artists, art, and
art history first emerged: the concept of art-making as primarily an
aesthetic rather than a functional activity ('art for art's sake'); the
image of the artist as a creative and visionary genius; the idea that
art's goal is to imitate the natural world; and the notion of
inevitable artistic 'progress' through the ages.

In many of the previous chapters, we considered 'Art' as a culturally
specific term that first began to be used in a way that we would
recognize today during the Renaissance, especially from the later
15th century onwards. Nevertheless, many of the images and
objects that we might now consider works of art would not

necessarily have been understood in this way by their original Renaissance makers and beholders. The same is true of the term 'artist'. Nowadays, we often simply assume that organizing art history by the names of individual artists is a perfectly natural and normal thing to do, whether in the monographic books we buy, the one-man exhibitions we attend, or the television documentaries we watch. But, actually, until the Renaissance this was not at all the norm. Indeed, as we have seen, in this period many of the objects and images produced would have been viewed first and foremost in terms of their patron, function, medium, or iconography, rather being associated with the name of the person who had made them.

Our present-day view of artists, much like our current understanding of 'Art', has very much been shaped by the 19th century, for it was in this period that emphasis decisively shifted from an artist's skill or ability to his or her individual creativity. In other words, there was a change from valuing an artwork as a carefully crafted object to valuing most highly an artist's concept or idea and, inevitably, the related personal, biographical, and even psychological traits that were believed to have shaped him or her. So, 'true' artists were now most prized for their imagination, inventiveness, spontaneity, and creative self-expression even if or, better yet, especially if these traits resulted in artists leading unconventional lives touched by a kind of creative madness. The result was that artists were inevitably assumed to be misunderstood, ignored, and maltreated by most of their comparatively dull, unimaginative, and conventional contemporaries. This is, in short, the Romantic 'starving artist in a garret' model of art history – one need only think of Vincent van Gogh, who famously never sold a single one of his works during his lifetime and who, in a moment of madness, cut off his own ear, before eventually committing suicide.

However, some aspects of this notion of the artist and, implicitly, of artistic genius can be dated back to the Renaissance and the rise of

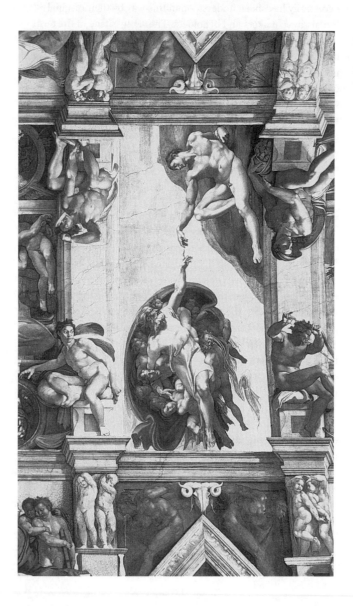

the first art-world 'superstars'. So, Michelangelo's melancholic fits, brooding personality, and temper tantrums (which led to his nose being broken in a youthful fight with a fellow artist), his astonishing creativity and artistic innovation, even his eccentric personal habits, such as wearing his leather boots for so long that they had to be cut off from his festering skin, all feature in contemporary biographies and depictions of the multi-talented artist who worked not only as a painter and sculptor, but also as an architect and a well-respected poet. Michelangelo himself saw his own creative powers as being divine and god-like. Not only was he pleased to be nicknamed 'The Divine One' (*Il Divino*) during his own lifetime, but many of the sonnets he wrote also equated the act of artistic creation with God's creation of Man. In fact, one can interpret Michelangelo's fresco of the Creation of Adam painted in c. 1508–12 on the ceiling of the Sistine Chapel in the Vatican (Figure 36) as a kind of metaphorical self-portrait in which the life-giving touch of God's hand is made comparable to the artist's own creative and generative hand. In the case of the marble *David*, Vasari explicitly states that Michelangelo's transformation of an old, botched piece of marble begun by another artist into an incredibly expressive figure was like 'a miracle in restoring to life something that had been left for dead' (see Figure 34).

What's in a name?

As we saw in the fifth chapter, Dürer, the most famous artistic superstar of the Northern Renaissance, made similar claims in his audacious self-portrait of 1500 by visually equating his own painted image with paintings portraying God the Father himself (see Figure 20). Dürer's prints also highlight another aspect of the changing status of the artist in the Renaissance. Whereas in past centuries, artists' names had generally not been recorded for posterity except accidentally in contracts and similar workaday documents and had

36. Michelangelo Buonarroti, *Creation of Adam*, fresco, c. 1508–12

almost never appeared on individual works of art, by the 15th century some artists had begun trying to distinguish themselves from their artisan and craftmen brethren by signing some of their works, as seen, for instance, in Jan van Eyck's boldly scrawled name on the back wall of the *Arnolfini Portrait* (see Figure 19). This trend becomes even more apparent in the 16th century, when signatures began to appear much more frequently on paintings, sculptures, prints, and sometimes even drawings. Significantly, Dürer's name appears prominently incised in his engraving of Adam and Eve in the Garden of Eden (see Figure 14). Here, Adam, the first human created by God, holds in his hand a sign very clearly stating 'made [*faciebat* in Latin] by Albrecht Dürer of Nuremberg' – but whether it was the print or Adam himself that had been 'made' by the German artist is left somewhat ambiguous, probably intentionally so.

Absolutely unambiguous is the role played by Dürer's name, or rather his monogram, in one of the first-ever incidents of artistic copyright violation. In this case, the Italian artist Marcantonio Raimondi copied (or perhaps one should say forged) some of Dürer's prints. The legal scuffle that ensued resulted in a decision allowing the copies to continue being printed, but only if they appeared without the 'AD' monogram. So, it was the presence or absence of the artist's name or monogram that seems to have been the key point of contention – for a Renaissance super-artist like Dürer, his monogram had apparently become something akin to McDonalds' golden arches or Chanel's double 'Cs' today, a guarantee of artistic quality and consistency through what we might call 'name-branding'.

It was also precisely to eliminate any ambiguity about authorship that Michelangelo decided belatedly to sign his name on one of his most important early sculptures, the famous marble *Pietà* in the Vatican, completed in 1499. Vasari, in his 'Life of Michelangelo', describes the young artist's anger upon hearing a loud-mouthed Lombard claim that the work had been made by a certain Gobbo of

Milan. So, later that evening, Michelangelo rapidly chiselled his name on the sash across the Virgin's chest, thereby very prominently and permanently ensuring that his authorship could never again be denied.

Vasari and the emergence of art history

The very idea of signing one's work is a reflection of a new understanding of the status of the artist, which first began to be articulated in the mid-15th century by the sculptor Lorenzo Ghiberti in his *Commentaries* and was then fully expounded in perhaps the most influential history of art ever written, Vasari's *Lives of the Painters, Sculptors, and Architects*, to give the work its full title, first published in 1550 and then again, in a revised edition, in 1568. Many of the approaches first codified in Vasari's *Lives* have been, and still continue to be, the basis for how art history is written. For instance, it is only very recently that scholars have seriously begun to question the Vasarian notion of artistic progress, of art apparently progressing teleologically towards some sort of unstated but implicit goal, first of naturalism and then of stylistic or formal innovation for its own sake. Although Ghiberti had already begun to develop his own preliminary model of artistic progress in the *Commentaries*, it was Vasari's grand narrative of art's history published a century later that became the key source of inspiration for the next five centuries of art historical scholarship.

Vasari's model raises as many questions as it answers. First of all, by reading the prefaces to each of the three sections of the *Lives*, one realizes that he believed the visual arts could go down as well as up in terms of their quality, style, and ingenuity. In fact, he describes the history of ancient art as being like the human life-cycle, in which youth is followed first by maturity and then, inevitably, by decline and death. A similar trajectory is applied to the art of his own epoch (broadly defined), which begins with what he calls the artists of the first period, such as Giotto. Vasari believed that, although these artists were far from perfect, they did mark the

beginning of a new era after what he felt had been centuries of post-Classical decadence and decay. Effectively, Vasari was giving the artists of this first age (who worked primarily in the 14th century) the equivalent of a 'best newcomer' award, even stating explicitly that they shouldn't be judged by the highest standards of art, but rather only in comparison to the 'barbaric' art (in Vasari's eyes) that had immediately preceded it. His second period covers most of the 15th century and, although Vasari admitted that art had improved greatly, nevertheless no artist managed to be perfect in all aspects of art-making. To continue our school prize-giving metaphor, then, this age would have received a 'most improved' award.

But no such qualifications were needed for the third period, which encompassed his own 16th-century contemporaries who, in Vasari's opinion, clearly merited 'most valuable player' awards or, in the case of Michelangelo, even a gold medal. Indeed, Michelangelo, the most 'super' of the superstar artists, had not only triumphed over his contemporaries, but had actually surpassed Vasari's two measures of perfection, namely, Classical art and the natural world:

> Michelangelo has triumphed over later artists, over the artists of the ancient world, over nature itself, which has produced nothing, however challenging or extraordinary, that his inspired genius, with its great powers of application, design, artistry, judgement, and grace, has not been able to surpass with ease.

In his 'Life of Michelangelo', Vasari displays both the strengths and the weaknesses of his approach. Having introduced each of his three sections with grand overviews of the period in question, he then states that it was not his intention simply to compile a list of artists and artworks. But, by using the individual artistic biography as his basic unit of organization, it is the individual artist who becomes the focus of attention, rather than, say, the patron or the original function of a work – a strategy that has remained at the

heart of much art historical writing until quite recently, and has often made it difficult to see beyond an artist's name when assessing an art object. But this approach does allow Vasari to make one of his key points, namely, that artists (including, of course, himself) should be accorded intellectual respect and high social status by the culture at large.

The ever more lofty status of the semi-divine artist, whom Vasari was eager to distinguish from what he saw as lowly artisans and mere craftsmen, is also suggested in the 'Life of Michelangelo' by the artist's association from an early age with the great and the good of his time. For instance, according to Vasari, Michelangelo was regularly invited to join the 'Magnificent' Lorenzo de' Medici at table when still a boy, while as a young man, he was willing and able to confront noblemen, cardinals, and even popes as his equals. In this important respect, the Renaissance artist differs from his Romantic successor: while the latter's biography is usually characterized by a constant stream of rejection by contemporary society, in the case of the Renaissance super-artist, it was precisely by demonstrating that he could interact with society's ultimate insiders, the members of the elite, that his high status as an artist was confirmed. For Renaissance artists like Dürer and Michelangelo, therefore, there would have been no glory in starving in a garret, unappreciated by their contemporaries. In fact, recent documentary research has proven just how rich Michelangelo actually was by the time he died, while Dürer marvelled at how well respected he was as an artist while on a visit to Venice: 'Here I am a gentleman'. The Renaissance artist could, however, adopt some of the moody eccentricities, if not the stigma of social exclusion, associated with the stereotypical modern and, indeed, postmodern artist.

In his 'Life of Michelangelo', Vasari deploys many of the approaches that still form the basis for sound art historical scholarship in the present day by considering issues such as provenance (that is, who the former owners of artworks were), patronage, iconography,

artistic antecedents, and stylistic analysis. So, for instance, he tells us how fragments of one of Michelangelo's cartoons ended up in the collection of a Mantuan nobleman, while the artist's often stormy interaction with his elite patrons is a topic returned to again and again throughout the 'Life'. Similarly, Vasari describes Michelangelo copying the works of two of the heroes of the first and second sections of the book, namely, Giotto and Masaccio. Amazingly, drawings by the young artist after both of these predecessors survive to this day, confirming Vasari's story. But Vasari's account also highlights some of the potential problems of focusing so relentlessly on an artist's life and personality. These fairly awkward and youthful sketches, like the cartoon fragments and other surviving scraps mentioned by Vasari, are, the writer repeatedly tells us, preserved like precious and holy relics. This inevitably turns the artist into a semi-divine figure whose every stroke of the pen or brush or chisel is worthy of quasi-religious worship.

The problem with being elevated to the status of mortal god, of course, is that artists can eventually start to believe their own spin. Indeed, in the case of Michelangelo, he even hired a man named Ascanio Condivi to write what was probably the first ever authorized artistic biography in order to try to gloss over claims in the first edition of Vasari's *Lives* that seemed to undermine Michelangelo's own carefully constructed image as an artistic super-hero whose genius was divinely inspired and completely innate. Among other things, Michelangelo wanted to deny the implication in the 1550 edition of the *Lives* that, rather than being God's gift to mankind, Michelangelo had actually had some training in the workshop of the painter Ghirlandaio, the artist who produced the altarpiece and frescos for the Sassetti Chapel discussed in Chapter 3 (see Figure 10). The result was that poor Vasari, without a doubt completely in awe of the great Michelangelo, was nevertheless forced to provide archival evidence in the second edition of the *Lives* to support his claims. In what might well be the first ever use of documentary evidence in art historical scholarship,

Vasari's 1568 edition quotes at length from a contract signed by Michelangelo's father, a document that clearly refutes the artist's assertion that he had never had a proper teacher.

Vasari's excursion into archival art history ends with the following phrase: 'I made this digression for the sake of truth, and it must suffice for the rest of his "Life".' But this is precisely one of the key problems of Vasari's text, namely, that it is far from a comprehensively documented collection of historical truths. Although many students and even some art historians continue to assume that Vasari's text can be used with confidence as evidence for what 'really' happened, in many instances it is clear that the *Lives* are as much an accumulation of hopes, desires, and myths as any work explicitly labelled as fiction. Obviously, Vasari had an agenda when writing the *Lives*, an agenda that centred around raising the status of the artist and defining the aim of art itself as being to try to surpass both nature and antiquity. And it is this agenda that underlies some of the more obviously and self-consciously constructed elements of the *Lives*. For instance, in a *topos* that can be traced back to Classical writers on art such as Pliny the Elder, Vasari repeatedly claims that artistic talent can be discovered by chance in childhood – a strategy that supports his assertion that artistic talent is something God-given rather than learned. So, although he insists that Michelangelo received some training from Ghirlandaio, he also emphasizes that Michelangelo's innate genius was already evident long before his apprenticeship began and that, once in the master's workshop, he soon surpassed his teacher.

Even more common is the *topos* of the artist who is discovered while tending sheep by a passerby who notices his untutored but nevertheless impressive sketches. We see this story for the first time in Vasari's 'Life of Giotto', in which the artist's talent was first discovered by the painter Cimabue while Giotto was tending his father's sheep and drawing pictures of animals on stones and in the sand. One could just about believe the story of one artistically

gifted shepherd boy, but in a later section of the *Lives*, Vasari tells the story of the Sienese painter Beccafumi, who is once again described as the son of a peasant, discovered this time by a Sienese nobleman while making drawings in the sand of the flock he was tending. Vasari gives nearly identical accounts about the early life and discovery of Andrea Sansovino and Andrea del Castagno as well, which simply must be more than mere coincidence!

In a more subtle way, Vasari also employs certain motifs that echo from one super-artist's biography to the next. So, he tells the tale of a young Michelangelo, who, while copying a German print of St Anthony attacked by devils, went out and bought strangely coloured fish to help him draw the monstrous malign spirits. Similarly, in the 'Life of Leonardo', Vasari claims that, again as a young boy, the artist painted a horrible monster after gathering everything from lizards and newts to snakes and maggots. According to Vasari, therefore, as boys both artists used local fauna to produce monstrous images – although, in Leonardo's case, Vasari provides a pungent additional detail by telling us that he became so engrossed in drawing from his creepy-crawly models that he didn't even notice the disgusting stench that developed as their carcasses started to rot.

The myth of Michelangelo

Most telling, though, is the example of Michelangelo, the undisputed hero of Vasari's *Lives*. As we saw in the fifth chapter, Michelangelo addressed a critic's complaint that his statue of a Medici duke did not resemble the sitter by asserting that, in a 1,000 years, no one would care what the duke had looked like, whereas all would remember the name of the man who had carved the sculpture. And, looking back at the Renaissance from the dawn of the 21st century, one has to admit that he may have been right: the cult of artistic genius and of the artistic masterpiece has continued to grow ever since Vasari's day. The often vicious

polemics generated by the recent restoration of Michelangelo's Sistine Chapel frescos suggest that the myth of the Renaissance artist, first and most fully embodied by this artist and so evocatively described by Vasari, is alive and well and still influencing how we assess the artworks produced in this paradigmatic period in the history of art.

The Sistine Chapel was perhaps the most bitterly contested programme of restoration in recent memory. There is no doubt that some areas of paint had started to flake off by 1980, when the project got underway, and that the paintings needed to be conserved, but the decision by the Vatican's art curators to undertake a complete restoration of the chapel's mural decoration went much further. The final result was that, rather than the dark, brooding genius familiar to centuries of art lovers and art historians, a new and improved Michelangelo emerged as a much brighter and lighter artist – literally as well as metaphorically, as seen in the cleaned *Creation of Adam* reproduced in the present volume.

'Before' and 'after' photographs of the restored frescos, which also included Michelangelo's *Last Judgment* on the chapel's back wall, document the dramatic changes that took place, with the artist transformed from the mad, bad, proto-Romantic genius of old into a very different kind of figure indeed. A number of prominent artists, including everyone from Andy Warhol to Robert Rauschenberg, joined by a vocal band of art historians, argued that the restorers were actually removing a final set of dark glazes Michelangelo himself had supposedly applied to the frescos in order to increase their sense of shadowy mystery. But the very thorough technical analysis undertaken by the restorers made it clear that the only glazes to be found were those applied by previous restorers who, among other things, had tried to clean the frescos centuries earlier with stale bread and sour Greek wine.

The new Michelangelo revealed by the restoration really shouldn't

have been such a great surprise. In fact, the clear, bright colours that emerged not only would have compensated for the fact that the frescos would have been seen from far below by beholders standing on the floor of the chapel, often under dark lighting conditions, but they were also very similar to those found in later 15th-century frescoes by Florentine painters such as Ghirlandiao, the artist to whom, as we have seen, Michelangelo himself had been apprenticed as a boy, despite his later denials. Indeed, although the colours aren't exactly the same, the general palette of Michelangelo's cleaned Sistine Chapel frescos is quite similar to that seen in the Sassetti Chapel. The problem, however, is that the first glimpse most late 20th-century beholders had of the restored frescos was not *in situ*, standing on the floor of the Sistine Chapel looking up, but rather in photographs, often taken from very close up, by the Japanese television company that had sponsored the restoration. This, of course, merely emphasized the almost fluorescent qualities of Michelangelo's colours when seen completely out of their original context.

If one keeps in mind how unrepresentative such photographs are of the experience of actually seeing the cleaned frescos *in situ*, then we can perhaps better understand just how shocking they must have seemed to those who suddenly saw long-familiar images like the *Creation of Adam* change so radically and so rapidly before their eyes. But whatever one's view may be of the Sistine Chapel restoration, the very fact that it caused such controversy and widespread public debate suggests just how enduring the Vasarian myth of Michelangelo as a dark, mysterious, and brooding artistic genius continues to be.

Conclusion

Clearly, it can be very difficult to really 'see' the artists as well as the art of 15th- and 16th-century Europe as Renaissance beholders would have done. However, by trying to reconstruct the original 'period eye' that would have gazed not only on a relatively small

number of works by the great Michelangelo, but also on many more images and objects produced by much less well-known or even anonymous artists and craftsmen, we can begin to move beyond considering only *who* produced a particular work of art, and instead start to understand *why* and *how* such works were made, used, and understood by their original Renaissance beholders.

References

Chapter 1

For Goethe's reaction to the Dresden Picture Gallery, see Carol Duncan, *Civilizing Rituals: Inside Public Art Museums* (Routledge, 1995), pp. 14–15. Cellini's description of casting the *Perseus* is found in *The Autobiography of Benvenuto Cellini*, trans. George Bull (Penguin Books, 1956), pp. 344–7. There are numerous editions of Jacob Burckhardt's *The Civilization of the Renaissance in Italy*: see, for instance, the one published by Harper and Row in 1958 in two volumes.

Chapter 2

Prior Ottobon's vision is described in Patricia Fortini Brown, *Venetian Narrative Painting in the Age of Carpaccio* (Yale University Press, 1988), p. 188. Alberti's praise of 'plain colours' is quoted in Michael Baxandall, *Painting and Experience in Fifteenth-Century Florence: A Primer in the Social History of Pictorial Style* (Yale University Press, 1972), p. 16. For the eye-witness account of iconoclasm in the Cathedral of Antwerp, see Jeffrey Chipps Smith, *The Northern Renaissance* (Phaidon, 2004), p. 365.

Chapter 3

Please note that a rectangular section of the canvas illustrated here as Figure 8 was cut away from the lower edge when it was moved from its original location and installed above a doorway in the Galleria dell'Accademia in Venice. There are many modern editions of Jacopo da

Voragine's *Golden Legend*: for instance, see the translation by William Granger Ryan published by Princeton University Press in 1993. Michele da Carcano's defence of religious images is quoted in Michael Baxandall, *Painting and Experience in Fifteenth-Century Italy: A Primer in the Social History of Pictorial Style* (Yale University Press, 1972), p. 41. On what makes a successful *istoria*, see Leon Battista Alberti, *On Painting*, trans. J. R. Spencer (Yale University Press, 1966), p. 75.

Chapter 4

For documentary information on the Master of Frankfurt, see Stephen H. Goddard, *The Master of Frankfurt and His Shop* (Paleis der Academiën, 1984). Alberti's codification of linear perspective is found in Leon Battista Alberti, *On Painting*, trans. J. R. Spencer (Yale University Press, 1966).

Chapter 5

On individuality and the idea of the 'Renaissance man', see especially Jacob Burckhardt, *The Civilization of the Renaissance in Italy* (Harper and Row, 1958), vol. I, p. 147, and vol. II, p. 303. For Alberti's notion of art depicting the inner person, see Leon Battista Alberti, *On Painting*, trans. J. R. Spencer (Yale University Press, 1966), p. 77. Dinteville's letter of 1533 is quoted in Susan Foister, Ashok Roy, and Martin Wyld, *Holbein's Ambassadors: Making and Meaning* (Yale University Press, 1997), p. 14.

Chapter 6

For Burckhardt's view of Renaissance women, see Jacob Burckhardt, *The Civilization of the Renaissance in Italy* (Harper and Row, 1958), vol. II, p. 389. Twain's comments on the *Venus of Urbino* are quoted in David Freedberg, *The Power of Images: Studies in the History and Theory of Response* (University of Chicago Press, 1989), p. 345.

Chapter 7

For Fra Giovanni Dominici's comments and the 4th-century text on the power of the maternal imagination, see Geraldine A. Johnson, 'Beautiful Brides and Model Mothers: The Devotional and Talismanic Functions

of Early Modern Marian Reliefs', in *The Material Culture of Sex, Procreation, and Marriage in Pre-Modern Europe*, ed. A. K. McClanan and K. R. Encarnación (St Martin's Press, 2002), pp. 143 and 151.

Chapter 8

Messer Francesco's comments are quoted in Geraldine A. Johnson, 'Idol or Ideal? The Power and Potency of Female Public Sculpture', in *Picturing Women in Renaissance and Baroque Italy*, ed. G. A. Johnson and S. F. Matthews Grieco (Cambridge University Press, 1997), p. 231.

Chapter 9

For Vasari's 'Life of Michelangelo', see Giorgio Vasari, *The Lives of the Artists: A Selection*, trans. G. Bull (Penguin Books, 1965), pp. 325–442; the quotations in the present chapter are found on pp. 338, 253–4, and 328. Dürer's comments on being an artist in Italy are cited in Joseph Koerner, *The Moment of Self-Portraiture in German Renaissance Art* (University of Chicago Press, 1993), p. 37.

Further reading

Chapter 1

Michael Baxandall, *Painting and Experience in Fifteenth-Century Italy: A Primer in the Social History of Pictorial Style* (Yale University Press, 1988)

Peter Burke, *The Italian Renaissance: Culture and Society in Italy* (Princeton University Press, 1986)

Jeffrey Chipps Smith, *The Northern Renaissance* (Phaidon, 2004)

Craig Harbison, *The Mirror of the Artist: Northern Renaissance Art in Its Historical Context* (H. N. Abrams, 1995)

John T. Paoletti and Gary M. Radke, *Art in Renaissance Italy* (Prentice-Hall, 2004)

Larry Silver, Henry Luttikhuizen, and James Snyder, *Northern Renaissance Art* (Prentice-Hall, 2003)

Evelyn Welch, *Art in Renaissance Italy, 1350–1500* (Oxford University Press, 2000)

Chapter 2

Michael Baxandall, *The Limewood Sculptors of Renaissance Germany* (Yale University Press, 1980)

Carlos M. N. Eire, *War against the Idols: The Reformation of Worship from Erasmus to Calvin* (Cambridge University Press, 1989)

Andrée Hayum, *The Isenheim Altarpiece: God's Medicine and the Painter's Vision* (Princeton University Press, 1989)

Peter Humfrey, *The Altarpiece in Renaissance Venice* (Yale University Press, 1993)

Peter Humfrey and Martin Kemp (eds), *The Altarpiece in the Renaissance* (Cambridge University Press, 1990)

Roger Jones and Nicholas Penny, *Raphael* (Yale University Press, 1983)

Chapter 3

Eve Borsook and Johannes Offerhaus, *Francesco Sassetti and Ghirlandaio at Santa Trìnita, Florence: History and Legend in a Renaissance Chapel* (Davaco, 1981)

Patricia Fortini Brown, *Venetian Narrative Painting in the Age of Carpaccio* (Yale University Press, 1988)

Thomas Kren and Scot McKendrick, *Illuminating the Renaissance: The Triumph of Flemish Manuscript Painting in Europe* (Royal Academy of Arts and J. Paul Getty Museum, 2003)

Henri Zerner, *Renaissance Art in France: The Invention of Classicism* (Thames and Hudson, 2003)

Chapter 4

Martin Kemp, *Leonardo da Vinci: The Marvellous Works of Nature and Man* (J. M. Dent, 1981)

Martin Kemp, *The Science of Art: Optical Themes from Brunelleschi to Seurat* (Yale University Press, 1990)

Erwin Panofsky, *The Life and Art of Albrecht Dürer* (Princeton University Press, 1971)

Roberto Weiss, *The Renaissance Discovery of Classical Antiquity* (Blackwell, 1988)

Chapter 5

Lorne Campbell, *Renaissance Portraits: European Portrait-Painting in the 14th, 15th and 16th Centuries* (Yale University Press, 1990)

Susan Foister, Ashok Roy, and Martin Wyld, *Holbein's Ambassadors: Making and Meaning* (Yale University Press, 1997)

Charles Hope, *Titian* (Jupiter Books, 1980)

Joseph Leo Koerner, *The Moment of Self-Portraiture in German Renaissance Art* (University of Chicago Press, 1993)

Nicholas Mann and Luke Syson, *The Image of the Individual: Portraits in the Renaissance* (British Museum Press, 1998)

Linda Seidel, *Jan van Eyck's Arnolfini Portrait: Stories of an Icon* (Cambridge University Press, 1993)

Joanna Woods-Marsden, *Renaissance Self-Portraiture: The Visual Construction of Identity and the Social Status of the Artist* (Yale University Press, 1998)

Chapter 6

Rona Goffen (ed.), *Titian's 'Venus of Urbino'* (Cambridge University Press, 1997)

Geraldine A. Johnson and Sara F. Matthews Grieco (eds), *Picturing Women in Renaissance and Baroque Italy* (Cambridge University Press, 1997)

Joan Kelly-Gadol, 'Did Women Have a Renaissance?', in *Becoming Visible: Women in European History*, ed. R. Bridenthal and C. Koonz (Houghton Mifflin, 1977), pp. 137–64

Cynthia Lawrence (ed.), *Women and Art in Early Modern Europe: Patrons, Collectors, and Connoisseurs* (Pennsylvania State University Press, 1997)

Caroline Murphy, *Lavinia Fontana: A Painter and her Patrons in Sixteenth-century Bologna* (Yale University Press, 2003)

Roy C. Strong, *Gloriana: The Portraits of Queen Elizabeth I* (Thames and Hudson, 1987)

Chapter 7

Patricia Fortini Brown, *Private Lives in Renaissance Venice: Art, Architecture, and the Family* (Yale University Press, 2004)

Charles Dempsey, *The Portrayal of Love: Botticelli's Primavera and Humanist Culture at the Time of Lorenzo the Magnificent* (Princeton University Press, 1992)

Geraldine A. Johnson, 'Beautiful Brides and Model Mothers: The Devotional and Talismanic Functions of Early Modern Marian Reliefs', in *The Material Culture of Sex, Procreation, and Marriage in Pre-Modern Europe*, ed. A. K. McClanan and K. R. Encarnación (St Martin's Press, 2002), pp. 135–61

Jacqueline Marie Musacchio, *The Art and Ritual of Childbirth in Renaissance Italy* (Yale University Press, 1999)

Dora Thornton, *The Scholar in his Study: Ownership and Experience in Renaissance Italy* (Yale University Press, 1997)

Peter Thornton, *The Italian Renaissance Interior, 1400–1600* (H. N. Abrams, 1991)

Christopher Wood, *Albrecht Altdorfer and the Origins of Landscape* (University of Chicago Press, 1993)

Chapter 8

Bonnie A. Bennett and David G. Wilkins, *Donatello* (Moyer Bell, 1984)

Gene A. Brucker, *Florence, the Golden Age, 1138–1737* (University of California Press, 1998)

Michael W. Cole, *Cellini and the Principles of Sculpture* (Cambridge University Press, 2002)

Geraldine A. Johnson, 'The Lion on the Piazza: Patrician Politics and Public Statuary in Central Florence', in *Secular Sculpture 1300–1550*, ed. P. Lindley and T. Frangenberg (Shaun Tyas, 2000), pp. 55–73

Adrian Randolph, *Engaging Symbols: Gender, Politics, and Public Art in Fifteenth-Century Florence* (Yale University Press, 2002)

Marvin Trachtenberg, *Dominion of the Eye: Urbanism, Art, and Power in Early Modern Florence* (Cambridge University Press, 1997)

Richard C. Trexler, *Public Life in Renaissance Florence* (Cornell University Press, 1991)

Chapter 9

Francis Ames-Lewis, *The Intellectual Life of the Early Renaissance Artist* (Yale University Press, 2000)

Howard Hibbard, *Michelangelo* (Harper & Row, 1985).

Waldemar Januszczak, *Sayonara Michelangelo: The Sistine Chapel Restored and Repackaged* (Addison-Wesley, 1990)

Ernst Kris and Otto Kurz, *Legend, Myth, and Magic in the Image of the Artist: An Historical Experiment* (Yale University Press, 1979)

Penelope Murray, *Genius: The History of an Idea* (Basil Blackwell, 1989)

Patricia Rubin, *Giorgio Vasari: Art and History* (Yale University Press, 1995)

Giorgio Vasari, *The Lives of the Artists: A Selection*, trans. G. Bull (Penguin Books, 1965)

Johannes Wilde, *Michelangelo: Six Lectures* (Oxford University Press, 1978)

Glossary

For artworks with unfamiliar subjects, whether religious or mythological, readers should consult an iconographic dictionary such as James Hall's *Subjects and Symbols in Art* (John Murray, 1974).

altarpiece: a devotional image showing one or more holy figures or a sacred narrative scene that serves as the visual focus of a Mass; some altarpieces have wings that can be opened and closed; see also *retable altarpiece*, *triptych*, *polyptych*, and *predella*.

anamorphosis: a deliberately distorted image that looks 'correct' from one particular point of view, usually to the left or right of the composition.

book of hours: a prayer book, often illuminated, used for private devotion.

buttress: a supporting structure built against a wall to hold up a roof or vault

cartoon: a full-scale drawing on a sheet of sturdy paper (known in Italian as *cartone*) used to transfer the outlines of a figure or composition onto the prepared surface of a wall, panel, or canvas.

cassone: a decorated wooden chest given to women on their marriage and used to store clothing, bed linens, and other objects associated with dowries.

casting: the process of making a bronze or other metallic object by pouring molten metal into a mould; in the case of larger statues, these are often cast as a thin shell, rather than as a solid piece of metal.

Ciompi: a nickname for wool industry labourers in Florence in the 14th century.

condottiere: a professional soldier-general who hired out his services to the highest bidder.

confraternity: a club or organization based on professional or neighbourhood ties that focuses on communal devotional activities, social events, and charitable acts.

desco da parto (plural: *deschi*): literally, a 'birth-tray'; these objects were usually circular in shape, often decorated with scenes related to childbirth, and used to bring food and drink to new mothers resting in bed.

Early Modern: the historical period that began after the late Middle Ages and extends from the *Reformation* in the early 16th century to the 18th century; often used as an alternative to *Renaissance*.

ex-voto: an offering (often in the form of a symbolic object, small painting, or plaque) made in thanksgiving for or in the hope of miraculous divine assistance.

fresco: a painting on wet lime-plaster on a wall or ceiling; full-scale designs are often transferred onto the plaster via *cartoons*.

frontispiece: the title page or first illustrated page of a book or manuscript.

gender: this term is used in the present volume to denote the social, political, and cultural differences between the masculine and the feminine at a particular historical moment; 'gender' encompasses a wider range of meanings than does the term 'sex', which refers only to biological differences between men and women.

genre: a generic type or form of art, such as an *altarpiece*, portrait, landscape, or still-life painting; also used in the phrase 'genre paintings' to refer to images of everyday life.

gesso: a thin, white, plaster-like layer put down as a ground on a wooden panel or sculpture before it is painted in oil or *tempera*.

grotta: literally, 'grotto', but can also refer to a small room.

guild: an organization of merchants or craftsmen in the same profession; artists' guilds became less common at elite levels in Italy in the 16th century, when they began to be superceded by officially sanctioned art academies.

humanism: in the context of Renaissance Europe, an interest in studying and reviving the art and literature of ancient Greece and Rome; also, a focus on human individuals in general rather than on the Divine.

iconoclasm: the deliberate destruction of images for personal, political, or religious motives.

iconography: the subject or meaning of an image; the 'story' that is being told in a narrative scene.

in situ: literally, 'on site'; in the original location.

intarsia: wooden panels inlaid with variously coloured pieces of wood, often forming an illusionistic still-life scene or spatial setting.

istoria: Italian term used by Leon Battista Alberti in the mid-1430s to refer to the narrative or story depicted in an image.

linear perspective: see *perspective*.

loggia: a vaulted arcade with bays open on one or more sides.

lustreware: ceramics decorated with iridescent, metallic glazes.

memento mori: a symbolic image or tableau designed to remind beholders of death and their own mortality.

nave: the main body of a church, running from the entrance to the altar and often subdivided by columns into three or more aisles.

panel painting: a painting on wood in which the surface has been smoothed out by a layer of *gesso*; either *tempera* or oil-based paint can then be applied.

patron: the person who commissions and pays for a work of art or architecture; he or she will often negotiate a detailed contract with an artist for a particular project.

pediment: triangular structure positioned over a building's façade (as in Classical temples) or, on a smaller scale, over a doorway or frame; often supported by columns or *pilasters*.

perspective: one-point linear perspective is a mathematically based technique in which objects and architectural spaces are depicted on a flat surface as if seen three-dimensionally through the use of orthogonal lines that recede to a single vanishing point; ideally, the vanishing point is at the eye level of the beholder.

pilaster: a decorative feature that looks like a flattened column and projects only slightly from its supporting surface.

polyptych: an *altarpiece* with more than three main sections or panels.

predella: a series of small images, often depicting narrative events, which is displayed below an *altarpiece*'s main panel(s).

pre-Lapsarian: literally, 'before the Fall', referring to the fall of Adam and Eve from a state of sin-free grace once they ate forbidden fruit from the Tree of Knowledge in the Garden of Eden.

provenance: an artwork's past owners, whether institutions or individuals.

quadrant: an instrument that takes angular measurements of the position of the stars and other celestial bodies, and thus can be used in navigation.

refectory: dining room in a convent or monastery where meals are eaten in common.

Reformation: the religious movement that began in the early 16th century as an attempt to reform the papacy and the Rome-based (Catholic) Church.

Renaissance: the historical period that began with the 14th-century *humanist* revival in Italy and then incorporated elite culture throughout Europe in the 15th and 16th centuries; sometimes used interchangeably with *Early Modern*.

retable altarpiece: from the Latin for 'behind the [altar] table'; a type of painted or sculpted *altarpiece* generally found in Northern Europe that consists of a central group of individual figures or, later, a single image, in either case flanked by shutter-like wings that can usually be opened and closed; often mounted above *predella*-like image(s) or reliquary containers.

ringhiera: the raised ceremonial platform in front of Florence's town hall.

signori: the patrician rulers of Florence in the later 14th and 15th centuries.

stigmata: according to Christian tradition, the miraculous appearance of Christ's wounds on the body of St Francis.

studiolo: a small room in a palace or urban town house used by elite patrons as a study and to display and store their collections of

small-scale artworks, Classical artefacts, books, and exotic specimens from the natural world.

tempera: a matte, egg-based paint applied to *gesso*-covered wooden panels or sculptures; over the course of the 15th and early 16th centuries, generally replaced by oil-based paints.

topos (plural: *topoi*): a stock, oft-repeated subject or theme.

triptych: an *altarpiece* with three main sections or panels, usually depicting one or more saintly figures.

trompe l'oeil: French phrase meaning to 'trick the eye'; used to describe illusionistic paintings that appear to be real.

vellum: a fine parchment made from calfskin on which ink or paint can be applied; often used for expensive illuminated manuscripts.

Index

Page references in *italics* refer
to illustrations.

R

S

T